CAMBRIDGE
At Its Best

COMMONWEALTH EDITIONS
BEVERLY, MASSACHUSETTS

CAMBRIDGE
At Its Best

PHOTOGRAPHS BY
ULRIKE WELSCH

ISBN-13: 978-1-933212-68-5

Cover and interior design by Anne Lenihan Rolland

Printed in Korea

Published by Commonwealth Editions, an imprint of Memoirs Unlimited, Inc., 266 Cabot Street, Beverly, Massachusetts 01915

Visit us on the Web at www.commonwealtheditions.com.

To see more photos by Ulrike Welsch, visit www.ulrikewelschphotos.com.

Cover photo: St. Paul Church, Dunster House, and Memorial Hall rise on the Harvard Square skyline.
Overleaf (title page): The area around Harvard Square is a walker's paradise on a warm summer evening. This shot up Winthrop Street looks toward Lowell House, built in 1930 as part of Harvard president Abbott Lawrence Lowell's plan to house all Harvard students in university-owned buildings.
Facing page: Architect Frank Gehry designed one of the more unusual buildings at the Massachusetts Institute of Technology—or anywhere else in Cambridge. The Ray and Maria Stata Center is an academic complex that opened in 2004 on the site of MIT's former radiation laboratory.

10 9 8 7 6 5 4 3 2 1

INTRODUCTION

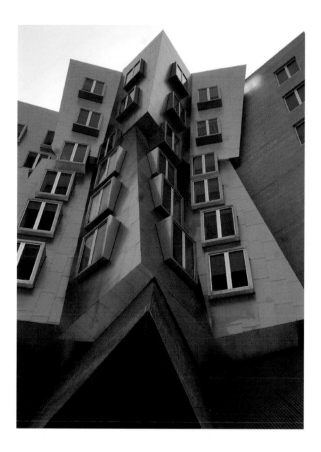

\mathscr{I} often begin my explorations of Cambridge at its navel, Harvard Square, where I arrive on the Red Line. From here I can easily visit Harvard Yard, cross over to the Coop, and take in the sounds at Passim or the Longy School of Music. From the square, I can head down to the river, where Memorial Drive is car-free on Sundays and autumn brings the Head of the Charles Regatta. Moving east I wind through the remarkable MIT campus with its Great Dome and eye-popping Strata Center, then on to Kendall Square where biotech shares space with a farmers market.

Both the Charles River and Fresh Pond are expanses for relaxation and activity during all seasons. I often find an oasis at Mt. Auburn Cemetery, where many great New Englanders sleep peacefully amid extraordinary natural splendor. Along my way through Cambridge I always manage to spot something unusual, whether it's a "River Rambler" riding the tidal waters of the Charles, a pair of brilliant brothers known as Click & Clack, or a lovely refuge atop a parking lot.

I would like to thank all of the Cambridge people and organizations who assisted me with thoughts, ideas, access, and opportunity in photographing this book. Every photo collection must be edited, and not all images could be used in the end. I would like to thank everyone at Commonwealth Editions for their help with this book, as with so many others before.

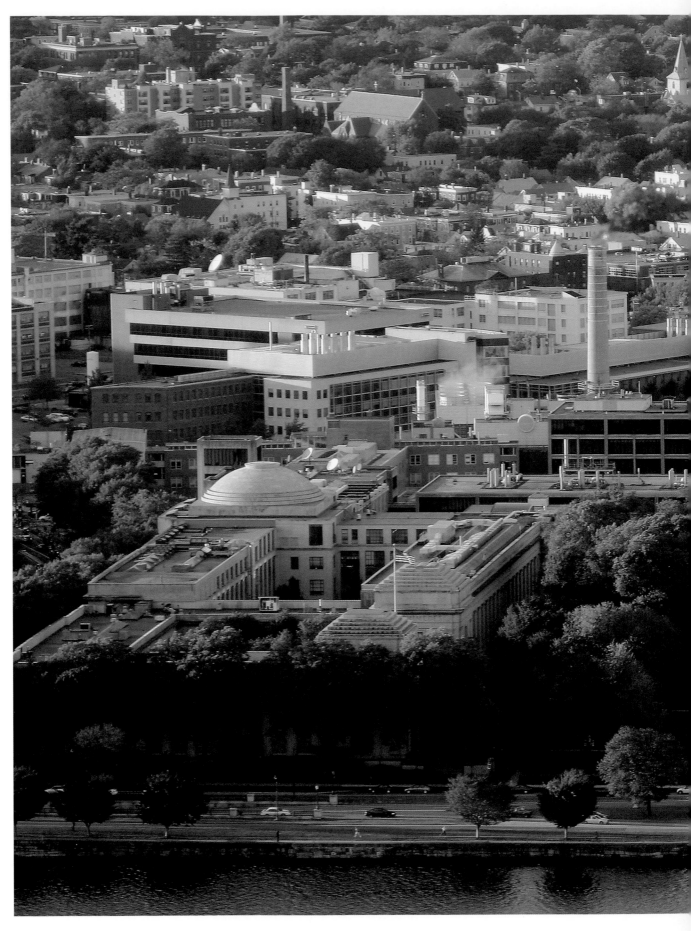

The Great Dome is the focus of the campus at the Massachusetts Institute of Technology—and of this aerial view of Cambridge taken from the top of the Prudential Center in Boston.

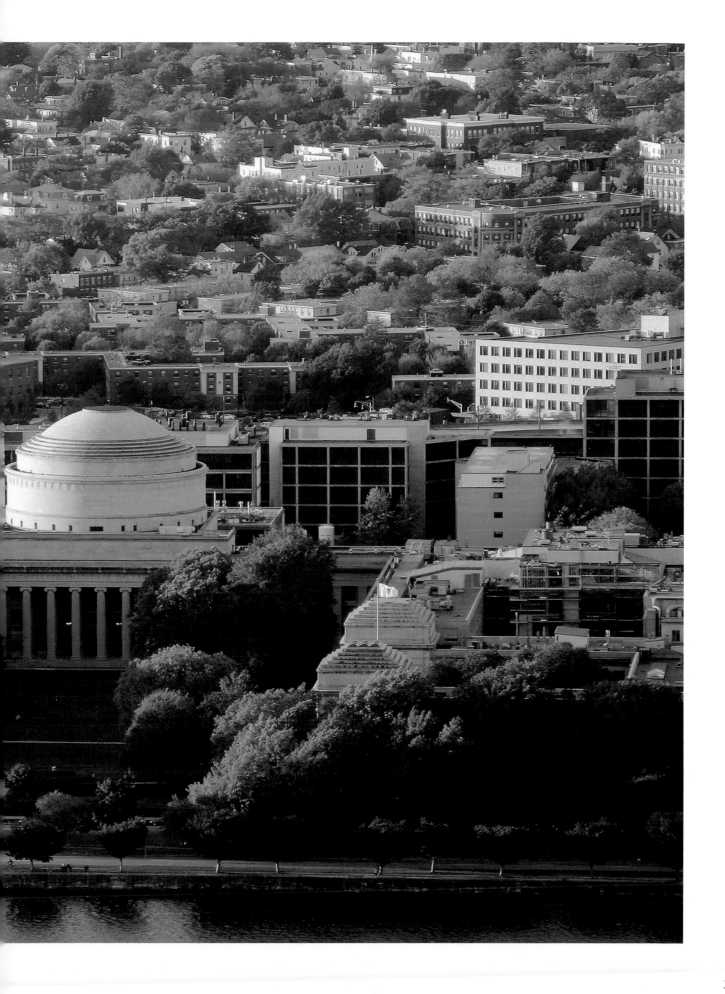

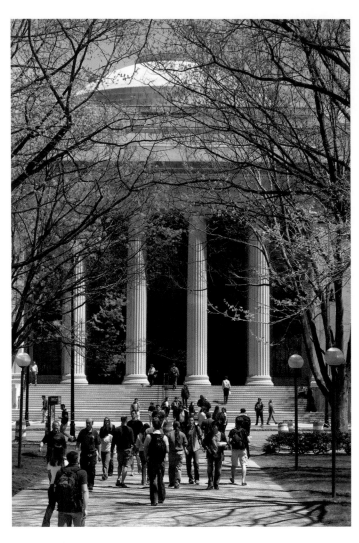

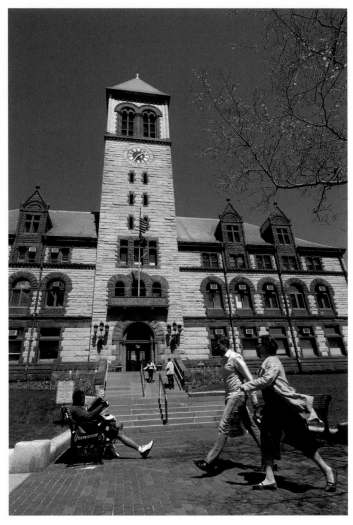

Designed by architect William Welles Bosworth, the Great Dome at MIT was among the first buildings erected on the Cambridge campus, during the First World War. MIT was originally located in Boston's Back Bay after the Civil War. It was then known as "Boston Tech."

Cambridge City Hall, at 795 Massachusetts Avenue between MIT and Harvard College, is a beautiful example of the Richardsonian Romanesque style of architecture, built in 1888–1889. Its bell tower is 158 feet tall.

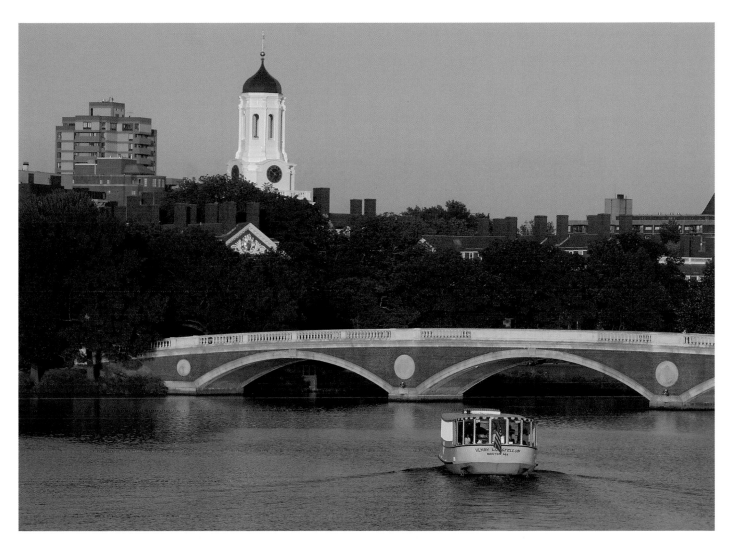

The Weeks Bridge is for foot traffic only, crossing from the main Harvard campus on the Cambridge side of the river to the Boston side, site of the Harvard Business School. Dunster House, with its red-topped tower, is a Harvard student residence built in 1930, one of seven given to the university by a single donor, Edward Harkness. The S.S. *Henry Longfellow* offers river cruises from its base at Canal Park in East Cambridge.

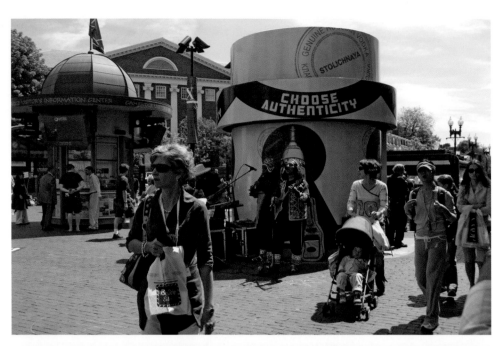

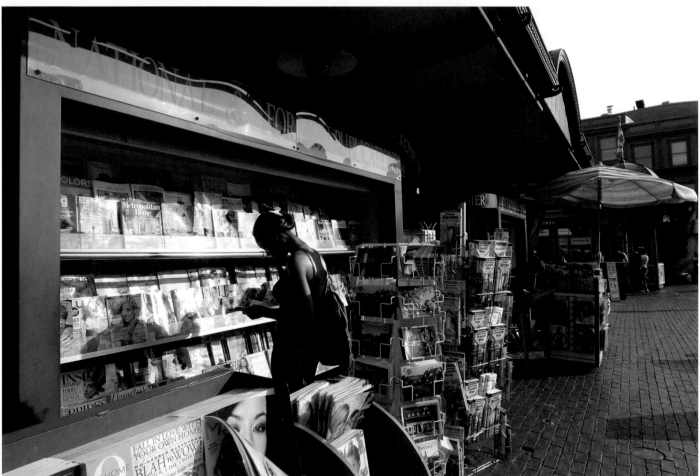

Top: "Authenticity" is one of the many values on display in Harvard Square, a focus of community and cultural life, and the hub of the Harvard campus. The site of every imaginable happening, it has been home or haven to everyone from seventeenth-century Puritan poet Anne Bradstreet to twentieth-century singer-songerwriter Tracy Chapman.

Bottom: Once a subway kiosk and now a newsstand, Out of Town News in Harvard Square offers newspapers and magazines from around the world.

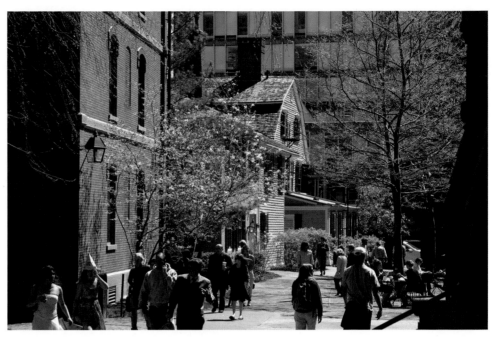

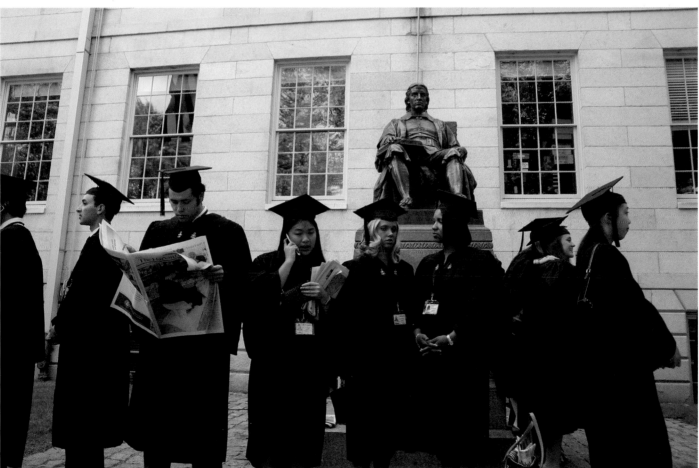

Top: Students cross Harvard Yard, the oldest part and center of the Harvard University campus. The oldest building on the Yard is Massachusetts Hall, dating from 1720. Wadsworth House, the yellow building here, houses the Harvard Alumni Association.

Bottom: John Harvard looks on from his pedestal as graduating seniors wait to join the procession for Harvard's commencement. The statue, cast by Daniel Chester French in 1884, commemorates the clergyman who bequeathed £779 and four hundred books for the college founded by the Massachusetts legislature in 1636. It was renamed in his honor in 1639.

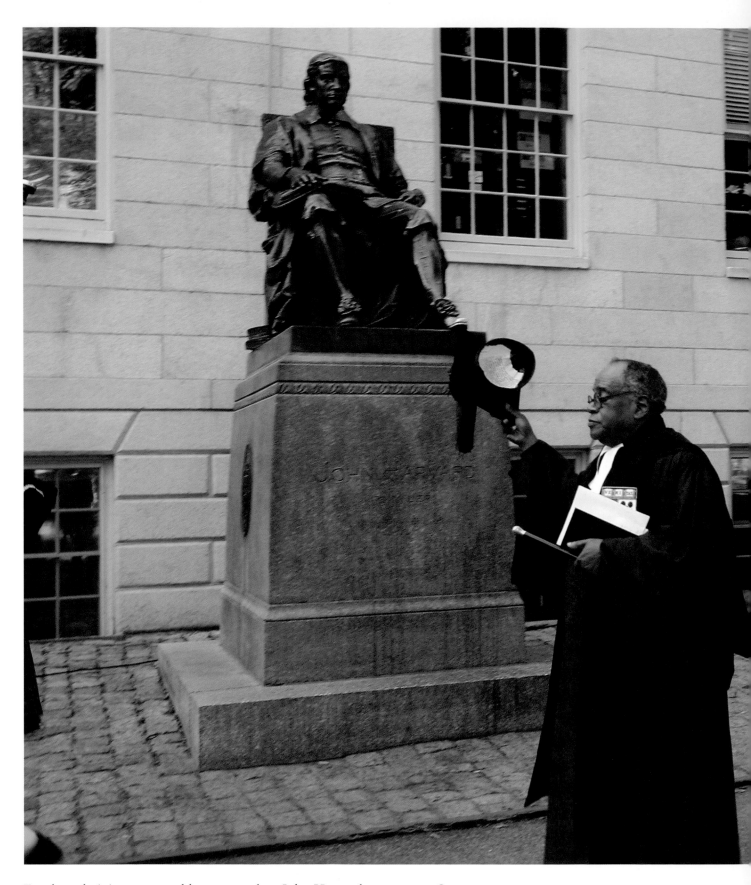

Faculty, administrators, and honorees salute John Harvard en route to Commencement.

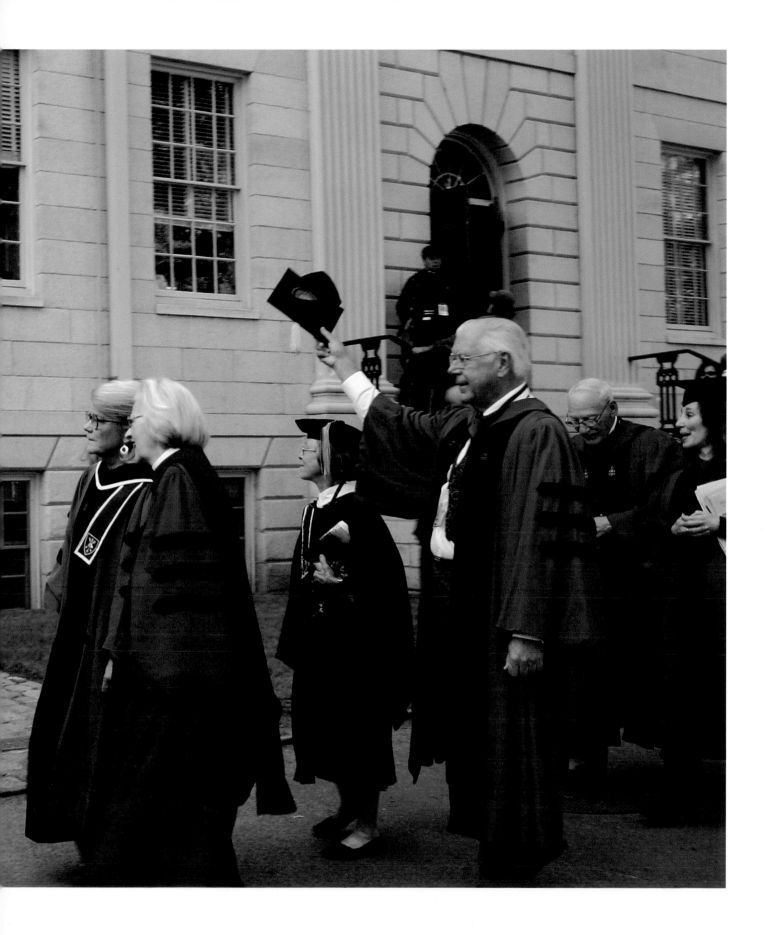

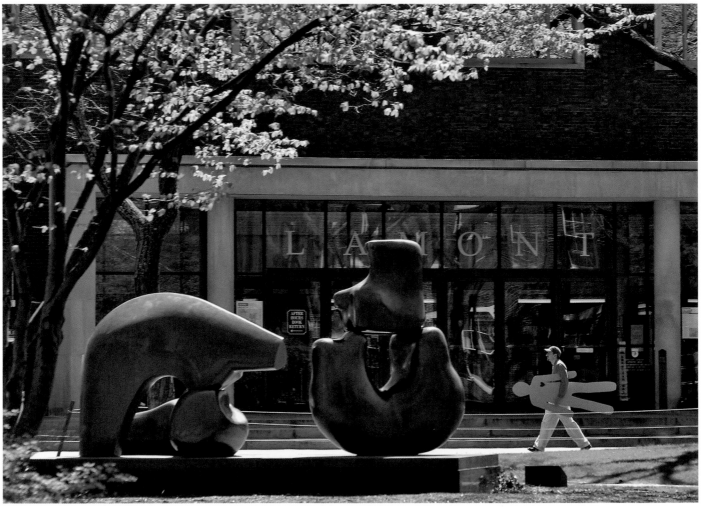

Top: Grendel's Den at 89 Winthrop Street, at the corner of John F. Kennedy Street, has been part of the Harvard Square scene since 1971.

Bottom: "Four-Piece Reclining Figure" by sculptor Henry Moore sits outside Lamont Library in Harvard Yard. Built in 1949, Lamont is the main undergraduate library at Harvard for humanities and the social sciences.

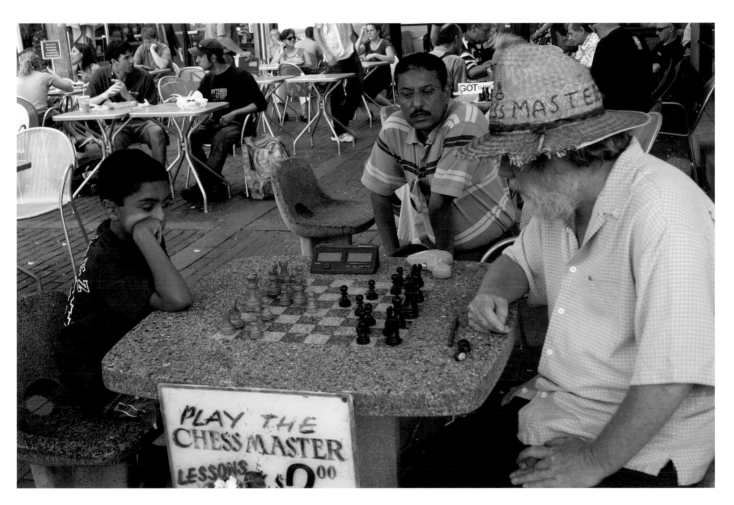

Chess masters may be a dime a dozen in Harvard Square, but for longtime denizens there is only one "Chess Master," at least only one that will happily play (and usually beat) you for $2 a try. Murray Turnbull has been at his post since 1982. With a rating of nearly 2400, he is truly a master.

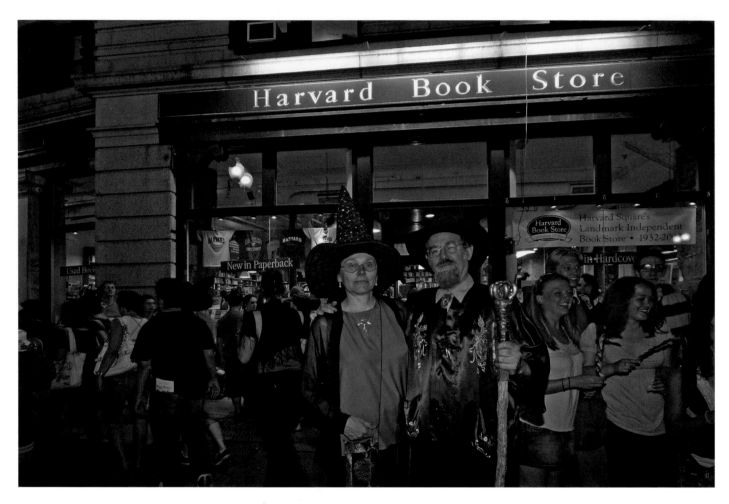

Above: The midnight launch of the seventh and final Harry Potter book brought crowds into Harvard Yard and Harvard Square, where witches and warlocks lined up at the Harvard Book Store.

Facing: Founded in 1882 as a cooperative run by Harvard students, the Harvard Coop is now one of the country's largest college bookstores, one that also sells everything Harvard.

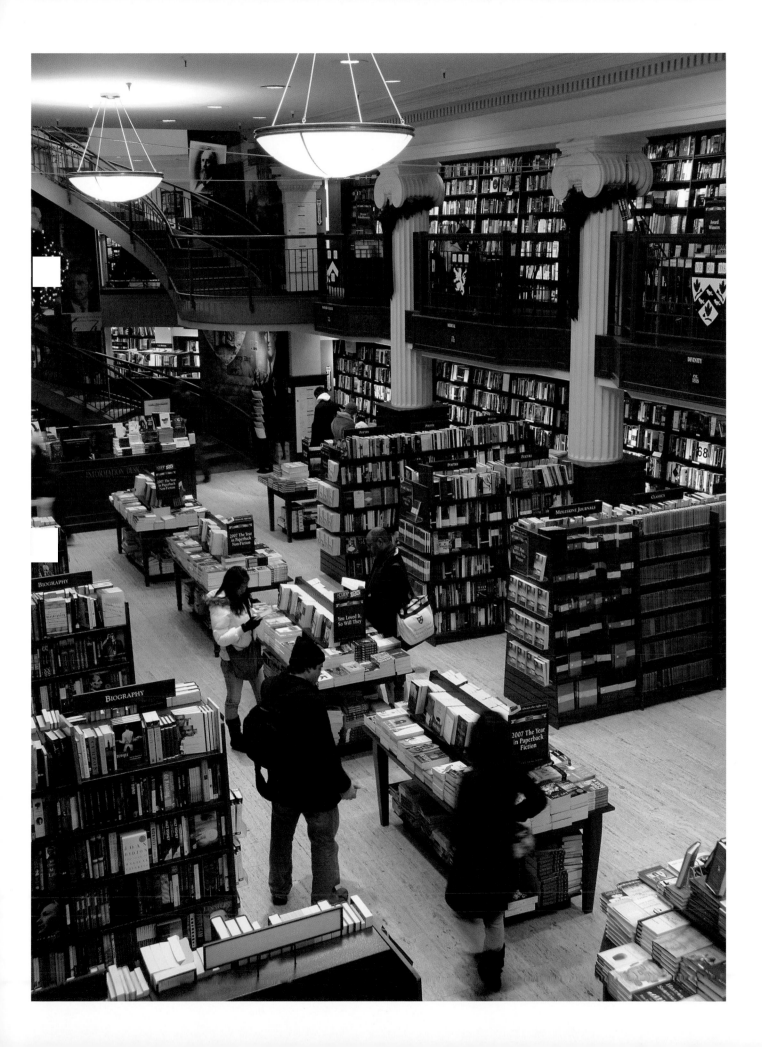

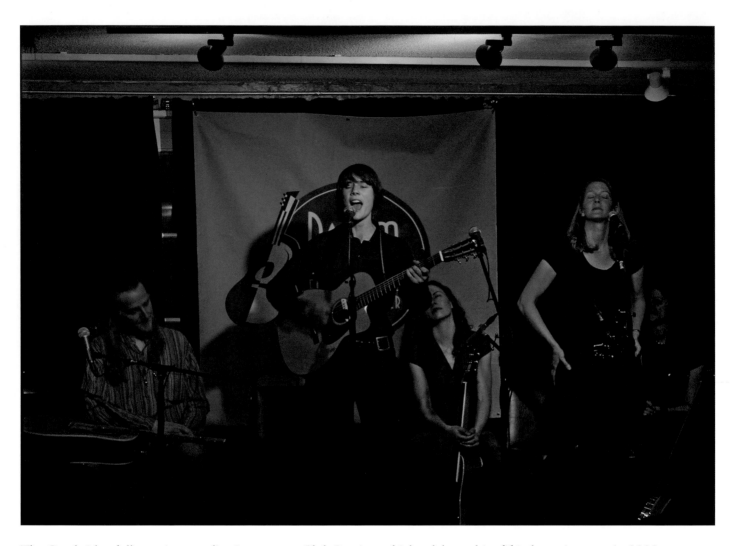

The Cambridge folk music scene has its roots at Club Passim, which celebrated its fiftieth anniversary in 2008. The Falcon Ridge Folk Festival's 2007 preview tour featured Ellis (singing) with Pat Wictor and Red Molly.

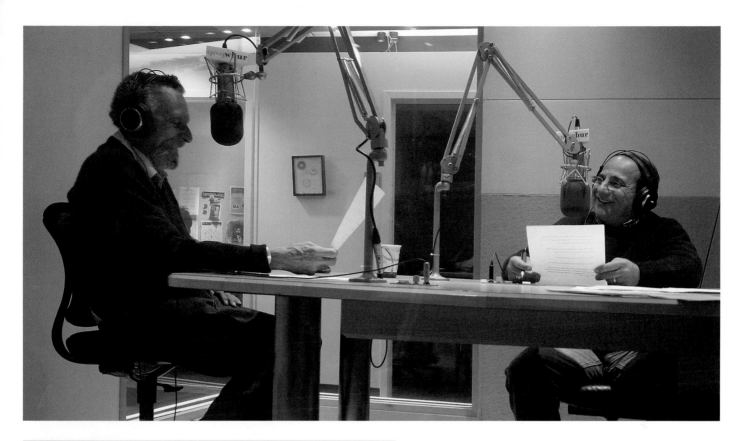

Above: Tom and Ray Magliozzi, a.k.a. Click
and Clack, a.k.a. The Tappet Brothers, are one
of the longest-running acts on NPR or any
other radio network. Their weekly program,
"Car Talk," broadcasts from studios facing
Harvard Square. The East Cambridge natives
talk tough, but talk smart: both are MIT
graduates.

Left: *The Harvard Lampoon,* in the humor
business since 1876, is most famous for its
parodies of mainstream magazines and of
Harvard's own daily newspaper, the *Crimson*.
John Updike and Conan O'Brien are just two
of the noted Harvard alumni who once toiled
in the distinctive headquarters building, a.k.a.
The Castle, off Harvard Square.

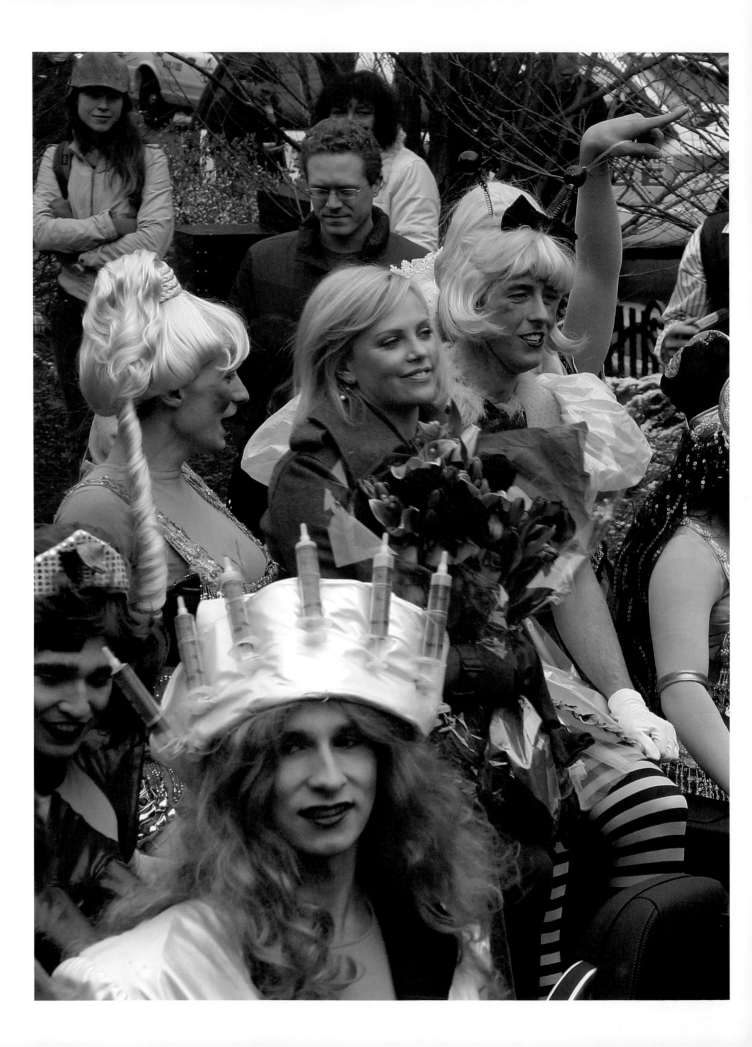

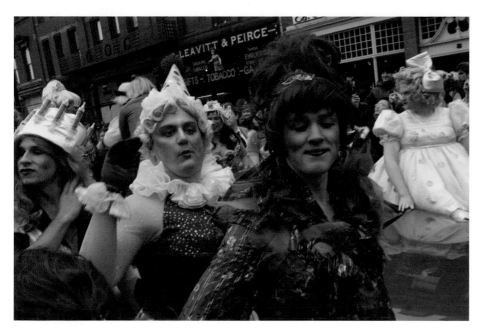

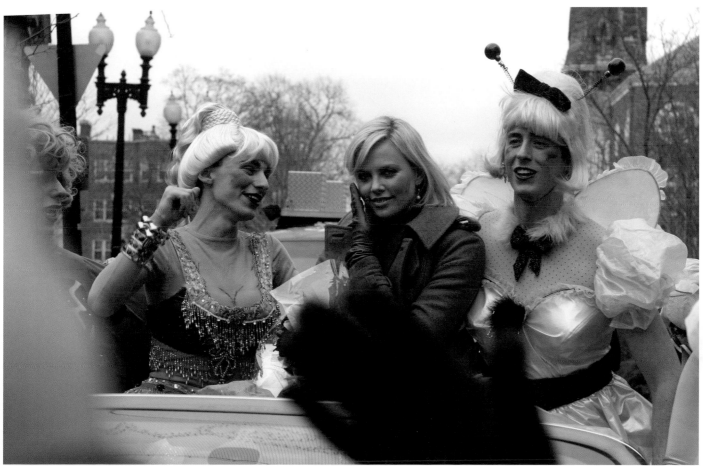

Hasty Pudding Theatricals at Harvard is the country's oldest undergraduate drama troupe. Actress Charlize Theron picked up the Pudding's 2008 "Woman of the Year" award, which amounted to receiving a golden pudding pot from an adoring group of Harvard men in drag. Theron was a good sport and the men were ravishing.

Above:
Below:

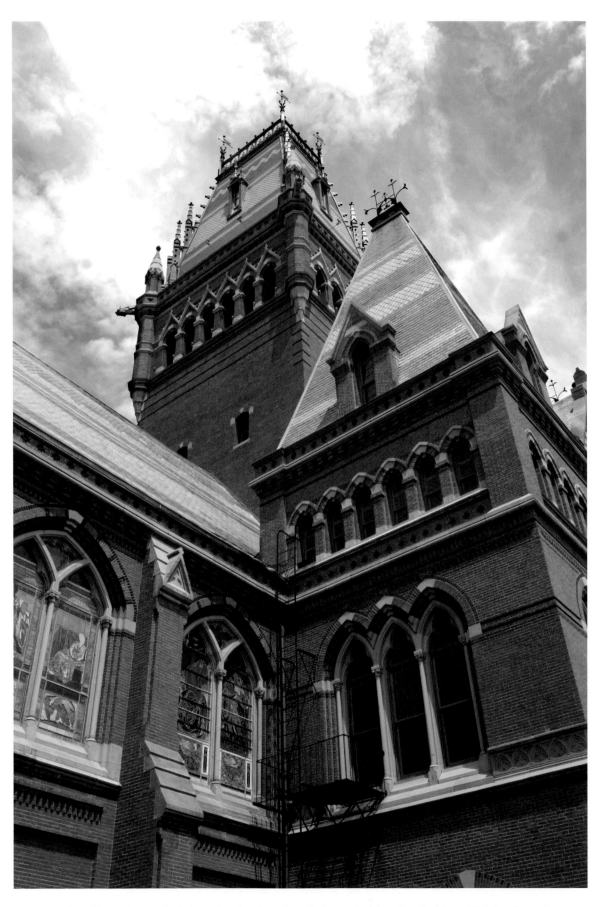

Memorial Hall at Harvard University, in the triangle bounded by Cambridge, Kirkland, and Quincy streets, was built after the Civil War as a tribute to those Harvard men who had fought for the Union cause. Sanders Theatre inside was built with a bequest from Charles Sanders, Harvard 1802. It continues to host a variety of concerts, lectures, and university events.

18

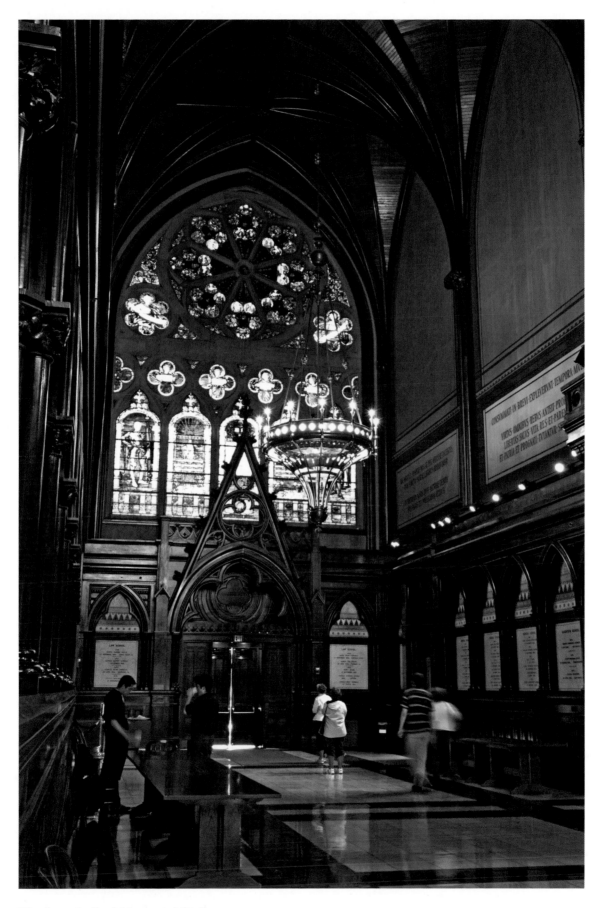

The front hall of Memorial Hall

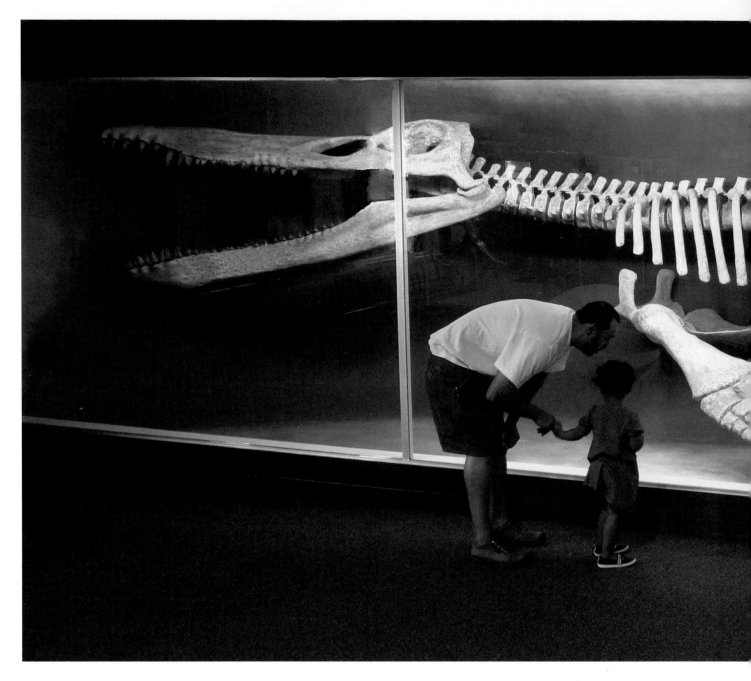

Above: This 42-foot skeleton of a kronosaurus, dating to about 135 million years BCE, is one of the many wonders on display at the Harvard Museum of Natural History on Oxford Street.

Facing: The Glass Flowers collection at the Harvard Museum of Natural History was created by the father-and-son team of Leopold and Rudolph Blaschka. Beginning in 1886 and working over five decades, the artists created three thousand models represting over 830 plant species, including this *Rhododendron maximum L.* (great laurel).

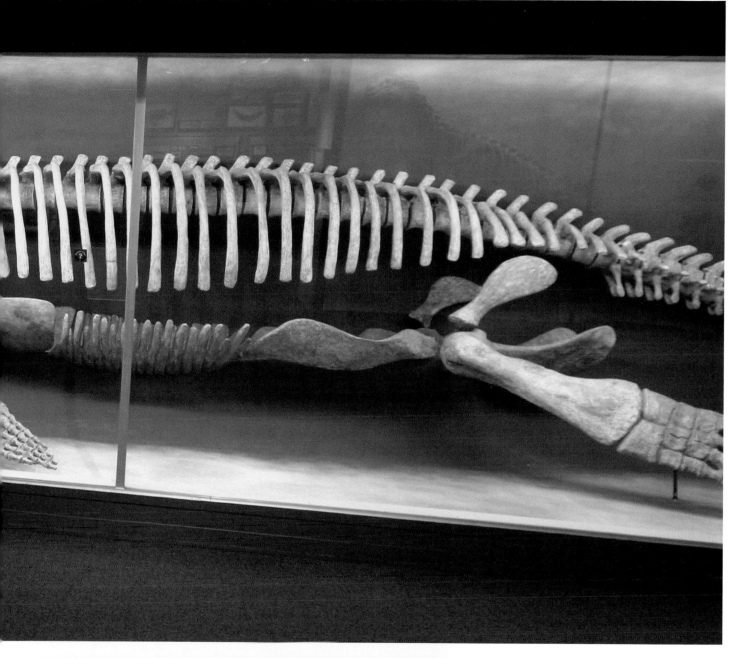

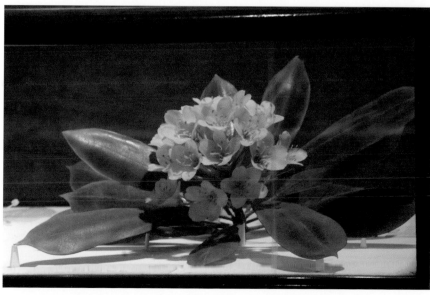

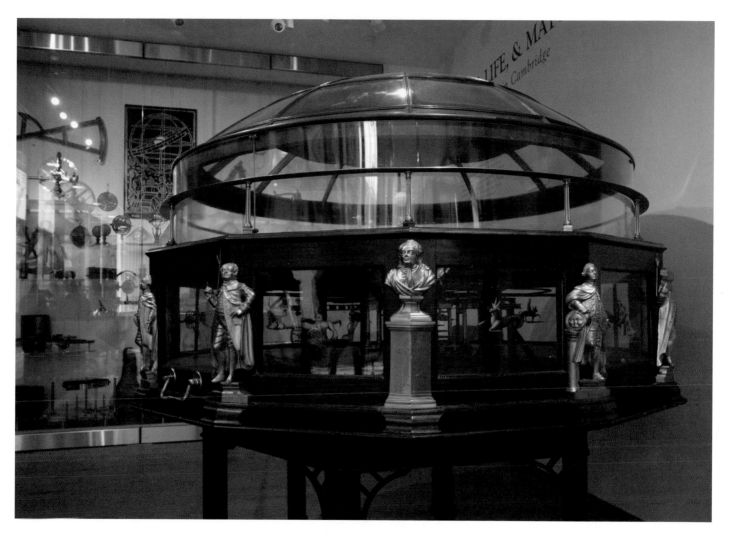

Above: On display in the Putnam Gallery of the Harvard Science Center is a collection of historical scientific instruments, including this Grand Orrery by Joseph Pope of Boston. Built between 1776 and 1786, this model of the solar system features a celestial dome supported by bronze figures cast by Paul Revere.

Facing: The Busch-Reisinger Museum at Harvard, on Quincy Street, is the only North American museum dedicated to the arts of central and northern Europe.

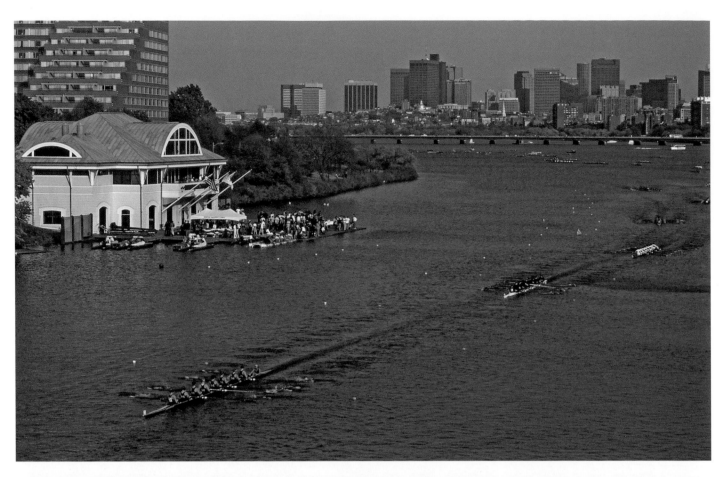

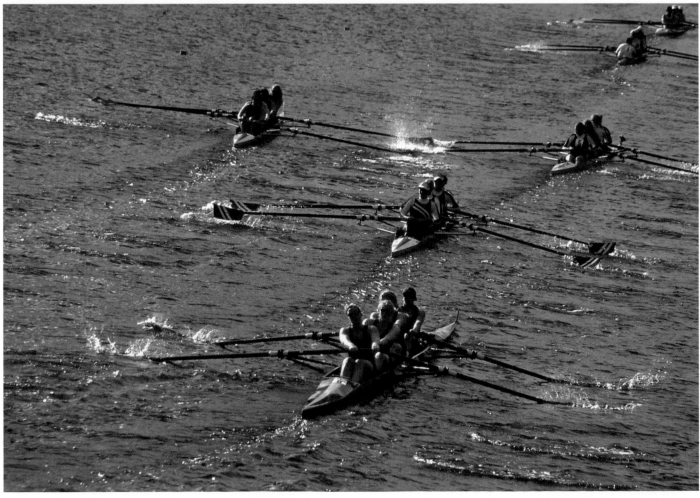

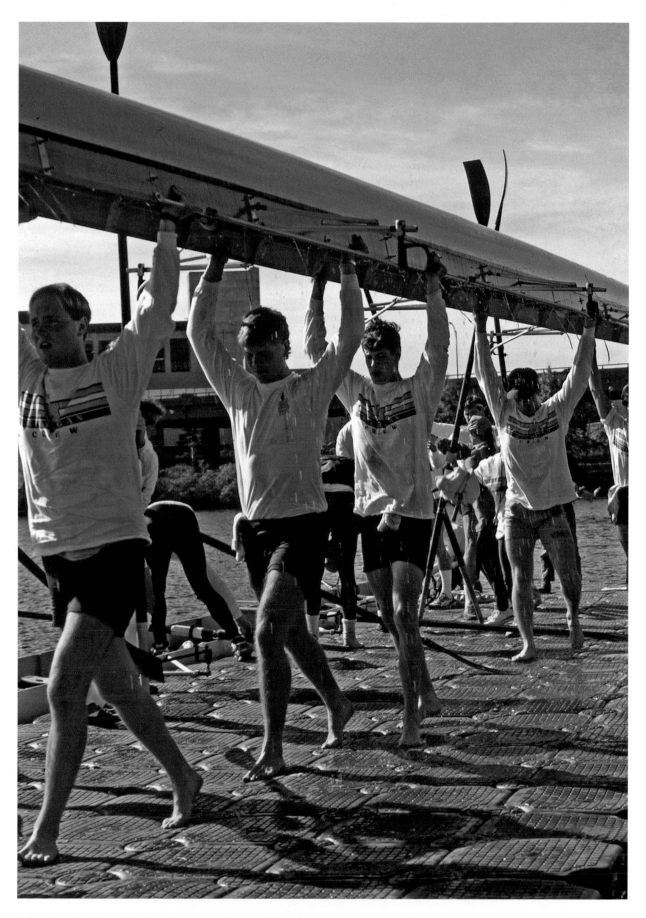

The Head of the Charles Regatta, the world's greatest two-day rowing event, was founded in 1965. It draws upwards of 7,500 athletes from around the world and as many as 300,000 spectators, who line the banks of the Charles to watch single sculls, pairs, fours, and eights.

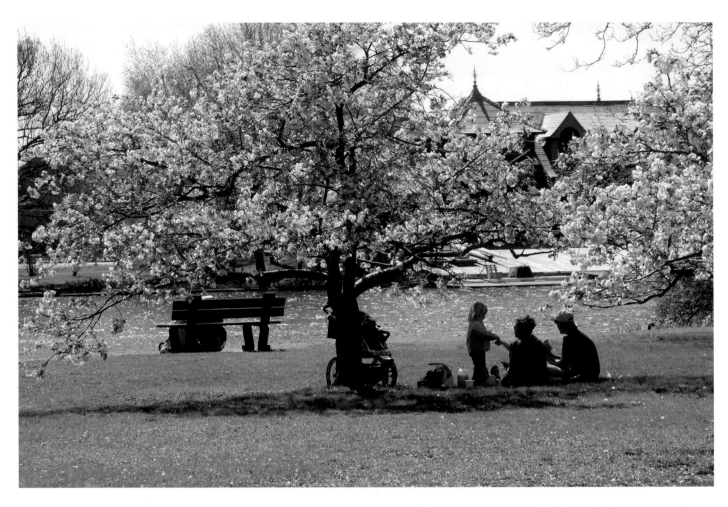

Spring trees blossom near the Larz Anderson Bridge. Harvard's Newell Boat House is visible through the trees on the Allston side of the river.

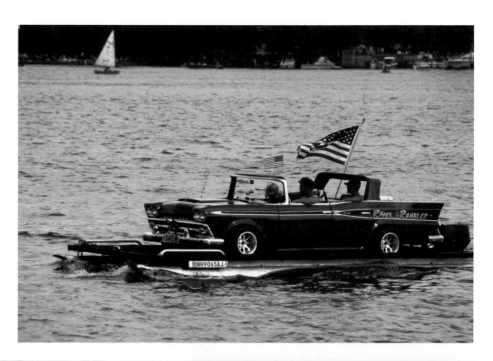

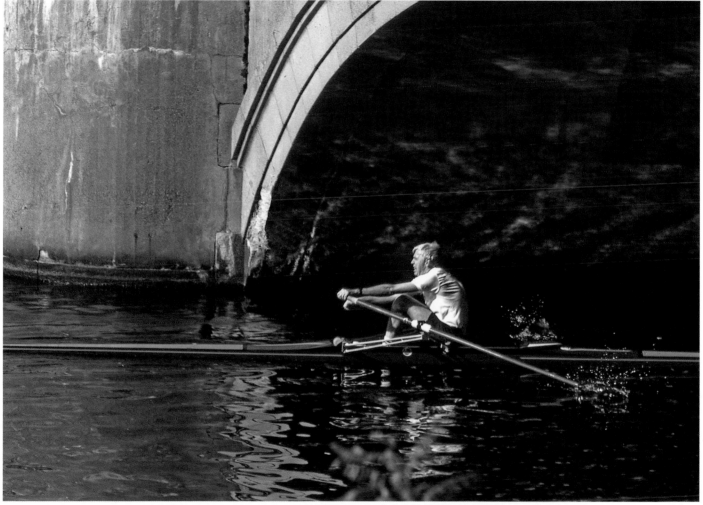

Top: Not every vessel on the river is serious about competition or even exercise. This "River Rambler" was afloat Independence Day, providing a great vantage point for the annual fireworks display that bursts over Cambridge and Boston.

Bottom: Rowing a single scull on the Charles River is a serene and solitary pastime.

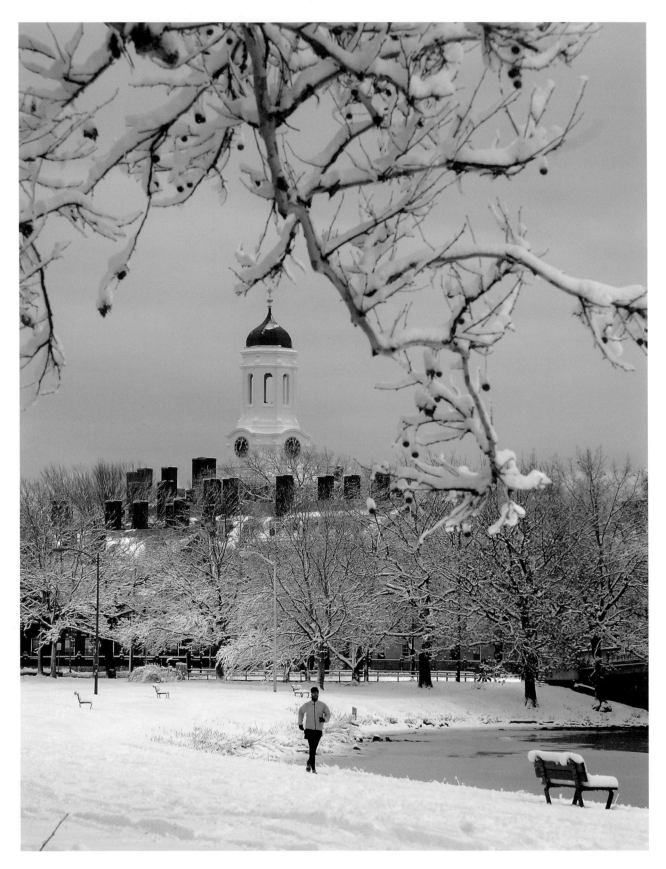

Above: Harvard's Dunster House stands tall in this winter scene along the Charles River.

Facing: Baker Library / Bloomberg Center, with its classic façade and bell tower, is the visible face of Harvard Business School as seen from the Cambridge side of the river. The collections here include 600,000 printed volumes, 4,000 working papers, 186,000 annual reports, over 1 million microform items, 23,000 linear feet of archives and manuscripts, 31,000 photographs, and nearly 4,000 periodicals—one of the finest business libraries in existence.

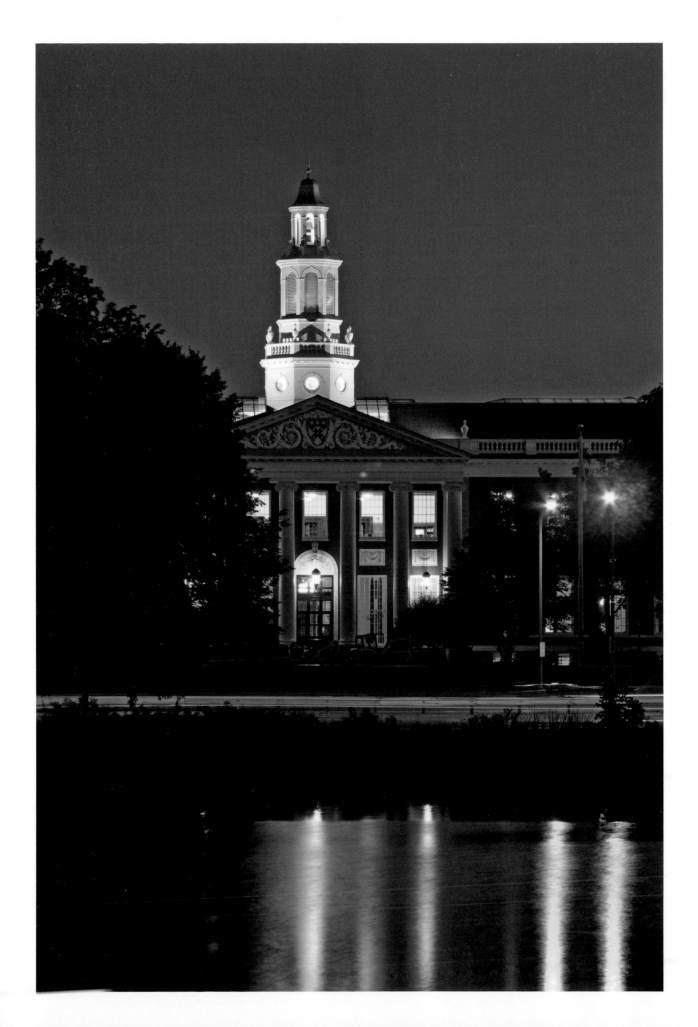

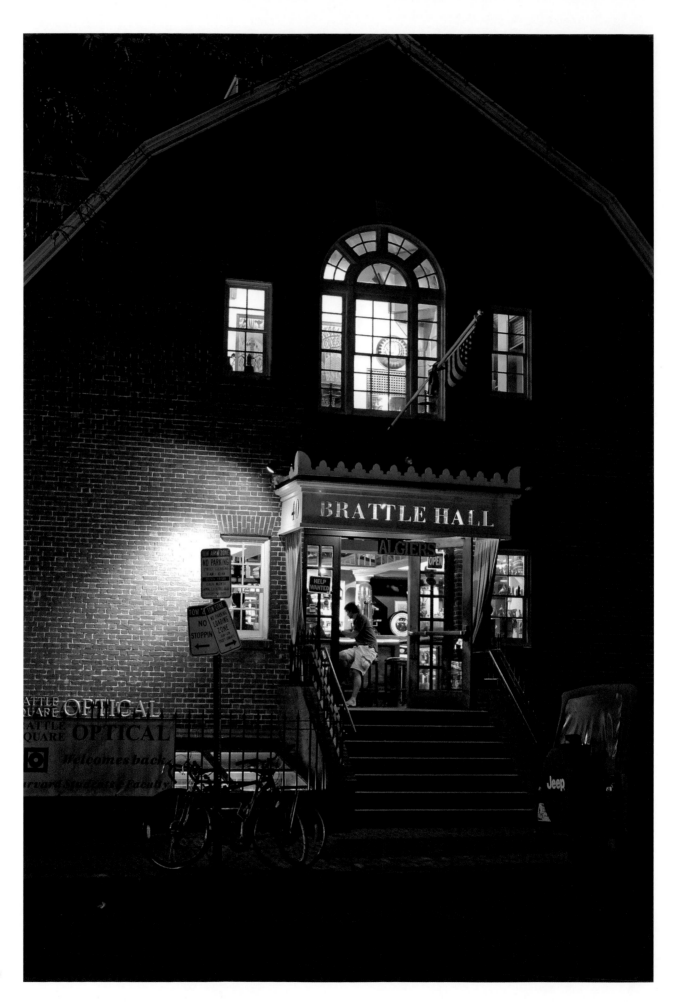

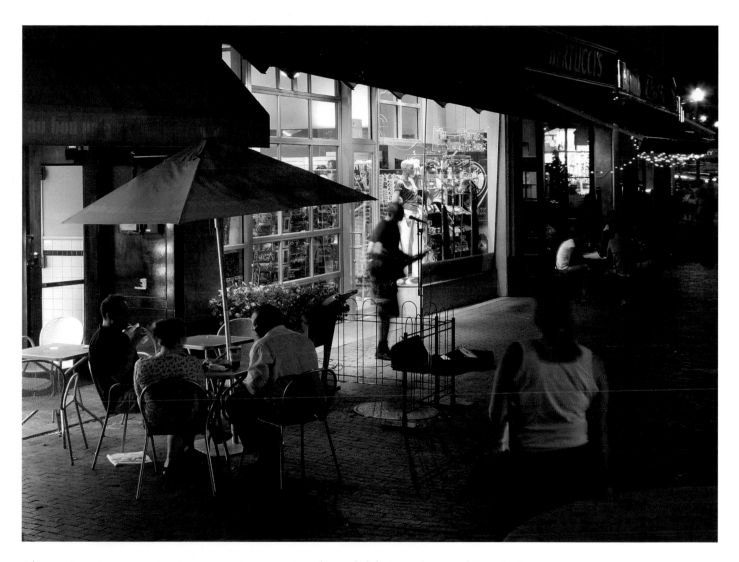

Above: A summer evening is a great time to enjoy the nightlife in and around Brattle Square.

Facing: Brattle Hall at 40 Brattle Street has a long history on the Cambridge cultural scene. Cofounded by the brother of Henry Wadsworth Longfellow, it first opened as a live theatre in 1890. Today it is home of the last remaining repertory movie house in Cambridge. Downstairs, the Café Algiers keeps alive the Humphrey Bogart cult that started on the Brattle's screen in the 1950s.

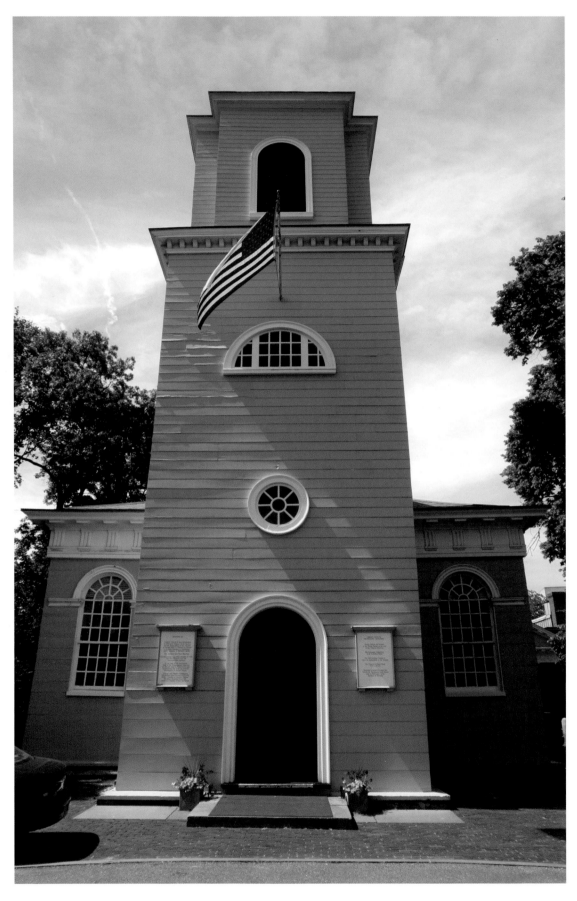

Above and facing: The congregation of Christ Church at Zero Garden Street was founded in 1759, and the Episcopal house of worship has a distinguished history: George and Martha Washington prayed here when the general was quartered at nearby Longfellow House, and Teddy Roosevelt taught Sunday school here.

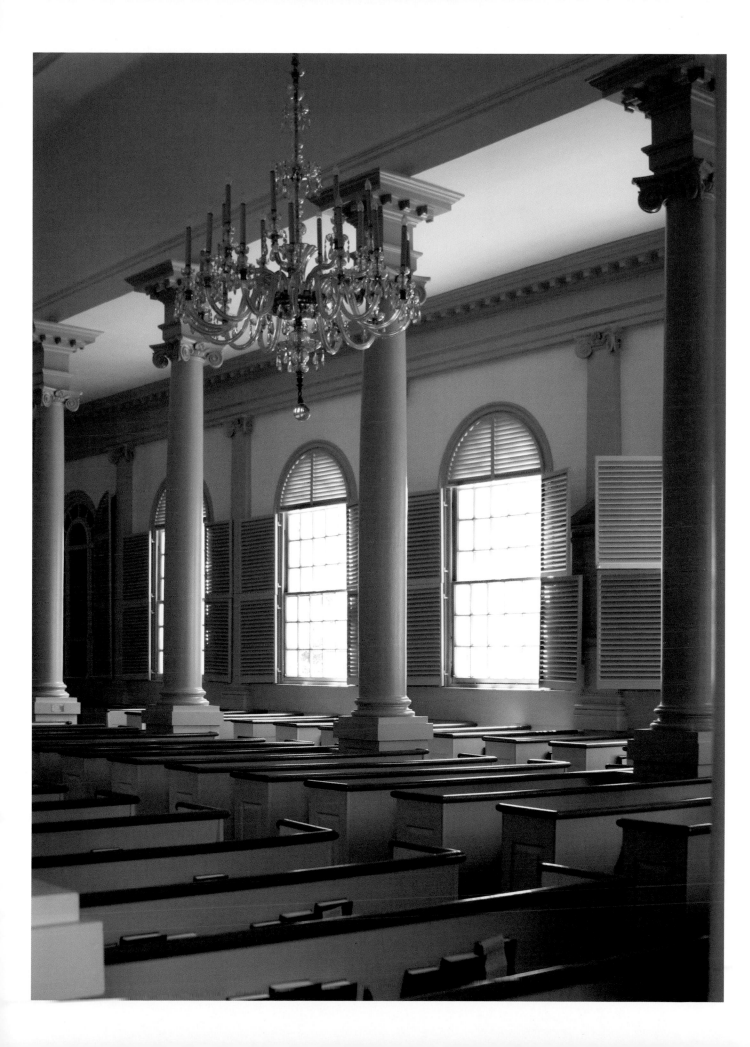

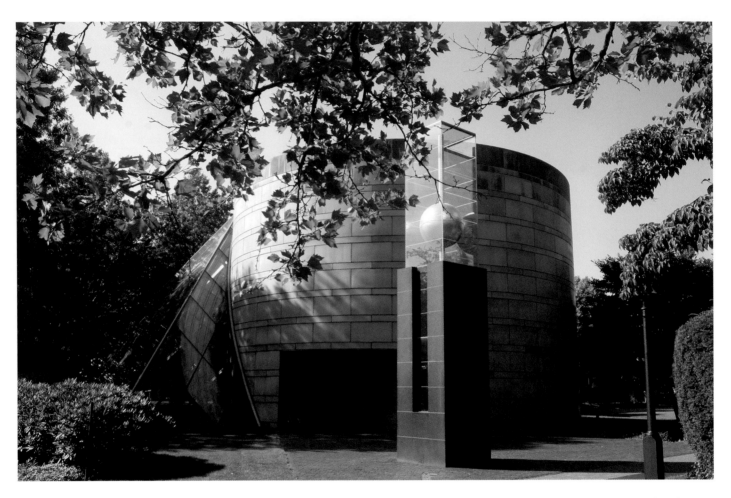

Designed by architect Moshe Safdie and completed in 1992, the Class of 1959 Chapel at Harvard Business School holds non-denominational services, celebrations, and concerts. The chapel also houses an intricately designed pond and is a popular spot for students seeking solitude and quiet.

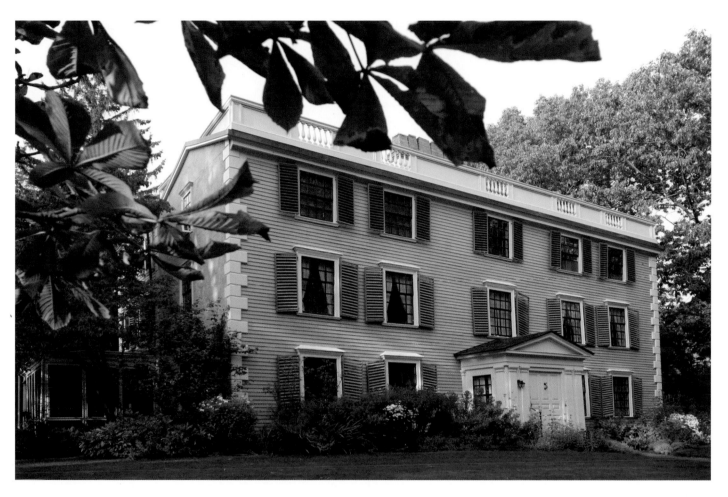

The Hooper-Lee-Nichols House at 159 Brattle Street is now home to the Cambridge Historical Society. Originally built around 1685, it has been modified and enlarged several times and is now considered a Georgian style building. In fact, it combines features of seventeenth-, eighteenth-, and nineteenth-century dwellings while serving a twenty-first-century organization.

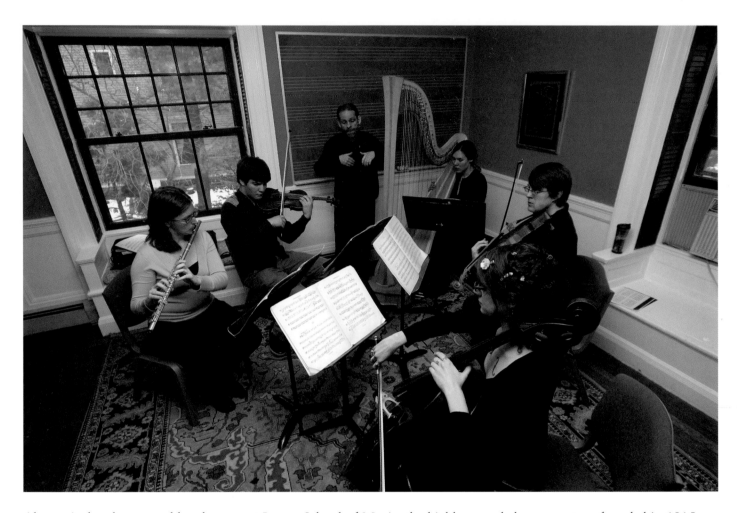

Above: A chamber ensemble rehearses at Longy School of Music, the highly regarded conservatory founded in 1915. Distinguished faculty have included the legendary Nadia Boulanger.

Facing: Radcliffe College, long one of the Seven Sisters and Harvard's coordinate college, formally merged with Harvard University in 1977. Agassiz House, named for nineteenth-century Radcliffe president Elizabeth Cary Agassiz, is now home to Harvard's undergraduate admissions and financial aid offices.

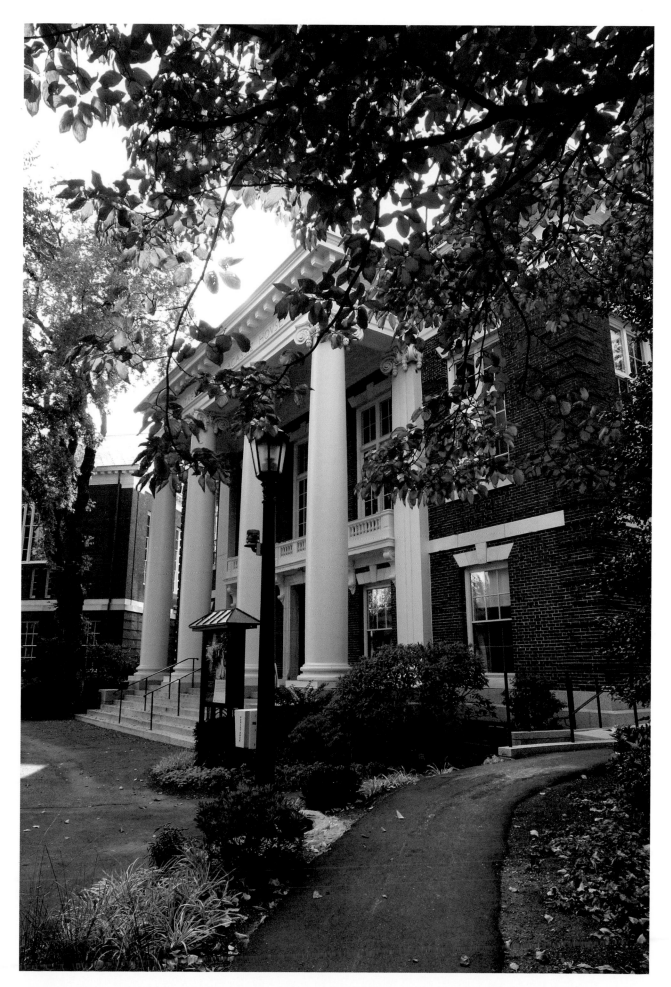

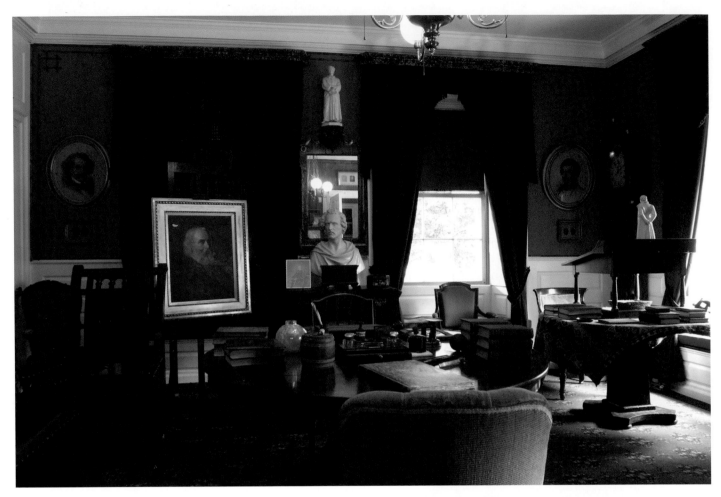

On display in the study of Longfellow House is a portrait of
the poet by his son Ernest, painted in 1876. The poet lived here
from 1846 to 1882. Previous resident George Washington is
commemorated by a bust in the front hall.

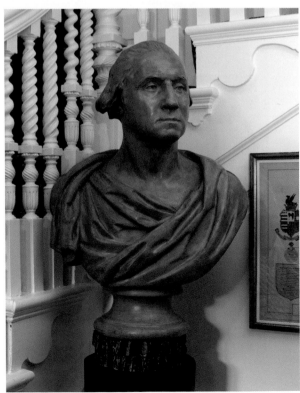

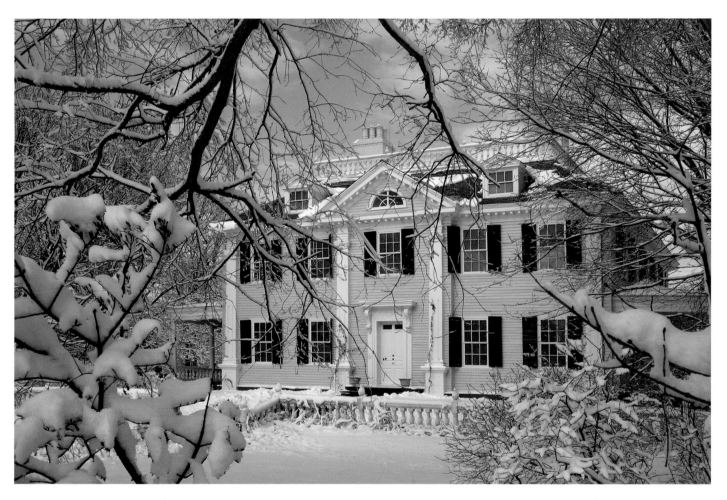

Longfellow House at 105 Brattle Street was headquarters for Gen. George Washington when he took command of the Colonial army and began planning the siege of Boston, but it is best known as the longtime home of one of America's greatest poets, Henry Wadsworth Longfellow. Charles Dickens was one of the luminaries who visited here.

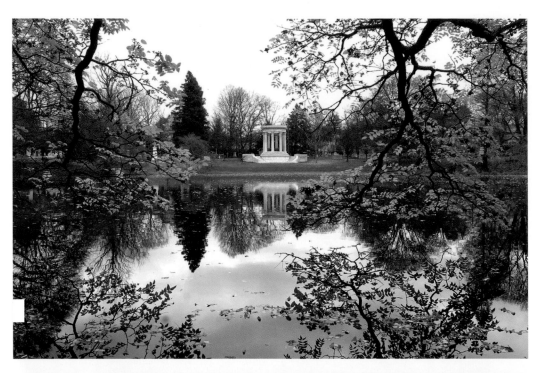

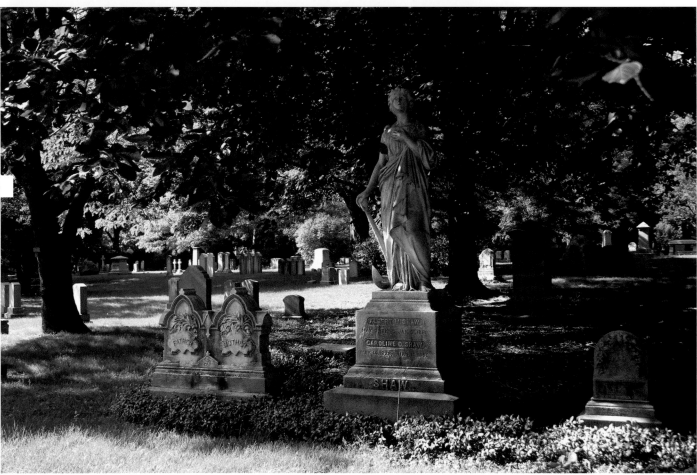

Top: One of the many famous "permanent residents" of Mt. Auburn Cemetery is Mary Baker Eddy, founder of the Church of Christ Scientist. The Lynn, Massachusetts, native is buried within the monument on the far side of Halcyon Lake.

Bottom: Mt. Auburn Cemetery was founded in 1831 as America's first "garden" or landscaped cemetery. Among the Boston luminaries buried here are architect Charles Bulfinch, art patron Isabella Stewart Gardner, poet Oliver Wendell Holmes, painter Winslow Homer, and architect Buckminster Fuller.

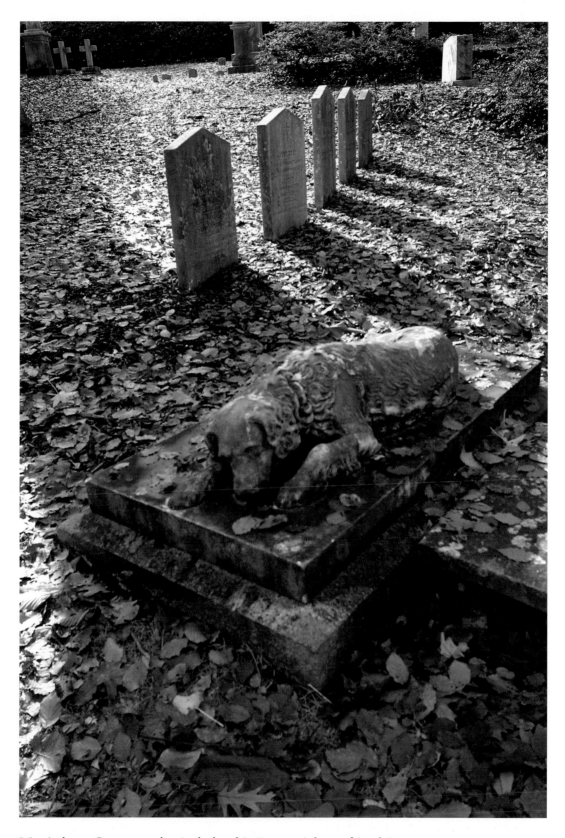

Mt. Auburn Cemetery also includes this "memorial to a friend."

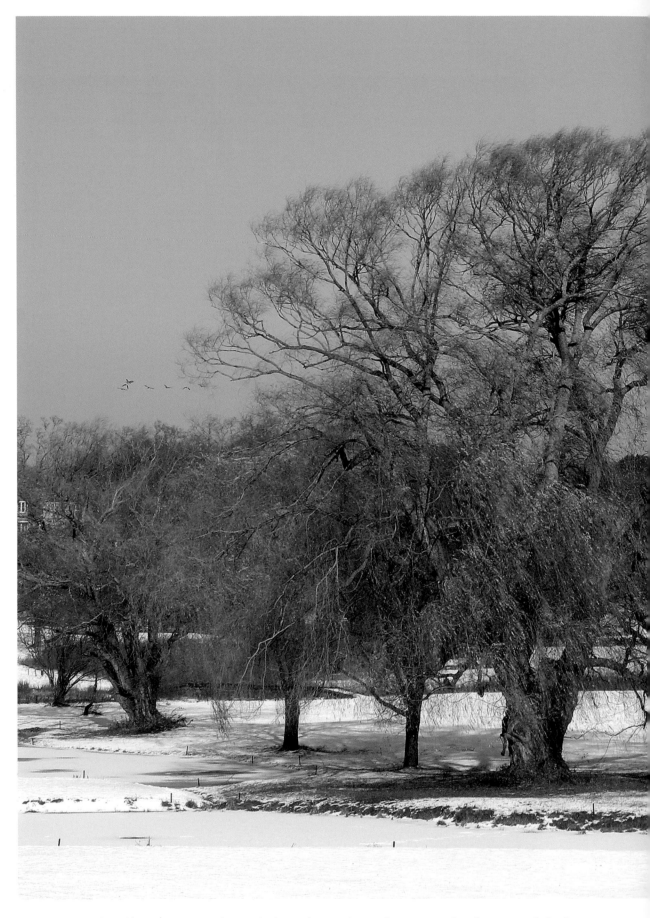

The Municipal Golf Course at Fresh Pond along the Fresh Pond Reservoir has been voted the best municipal golf course in Boston. Like many golf courses, the nine-hole layout is perfect for walking or cross-country skiing in wintertime.

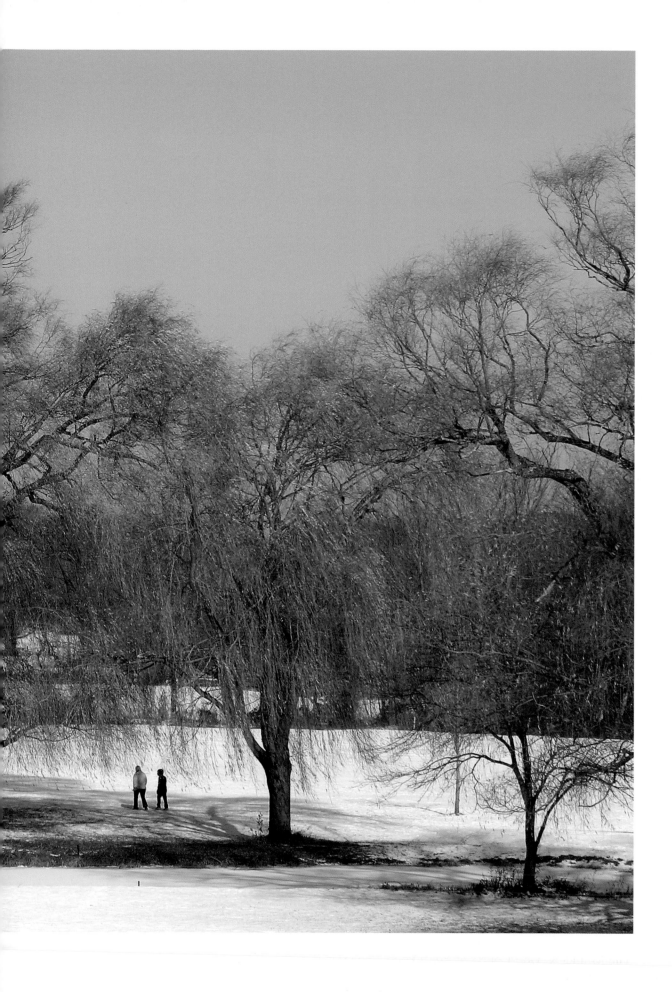

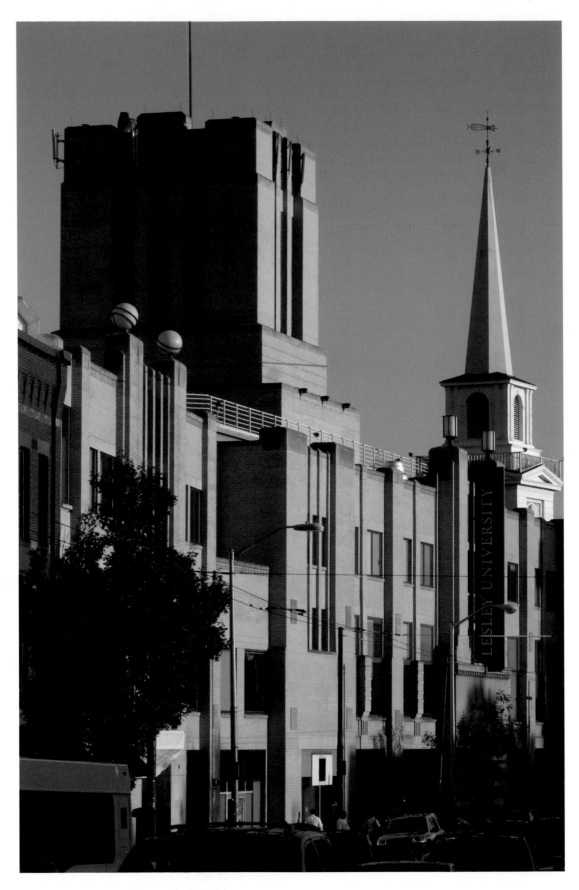

The former Sears Roebuck building in Porter Square, in Art Deco style, is now owned by Lesley University. Founded in 1909, Lesley offers undergraduate and advanced degrees that prepare women and men to become leaders in education, human services, the arts, environmental studies, and a variety of other professional fields. University Hall, as the old Sears building is now known, contains Lesley facilities as well as retail shops.

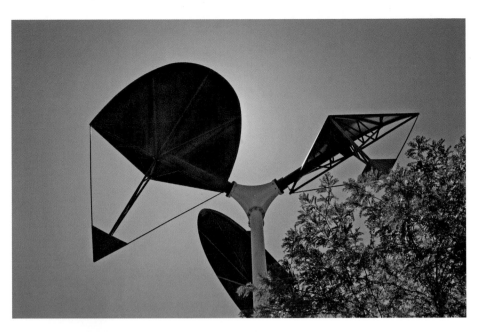

Top: This mobile at the Porter Square T station by Susumu Shingu is entitled "Gift of the Wind." One of Cambridge's most unusual and visible landmarks, it is 46 feet high. Its huge red wings are designed to respond to the winds, not only turning clockwise and counterclockwise but also tumbling over and over in surprising ways.

Bottom: The Cambridge mayor's office awarded its "Citation of Excellence" in 2000 for this mural on Davenport Street credited to Jeff Oberdorfer, Mass Art students, and Joshua Winer. Painted on the back of the Porter Square Shopping Area, the mural is actually several different works depicting the history and architectural styles of Porter Square.

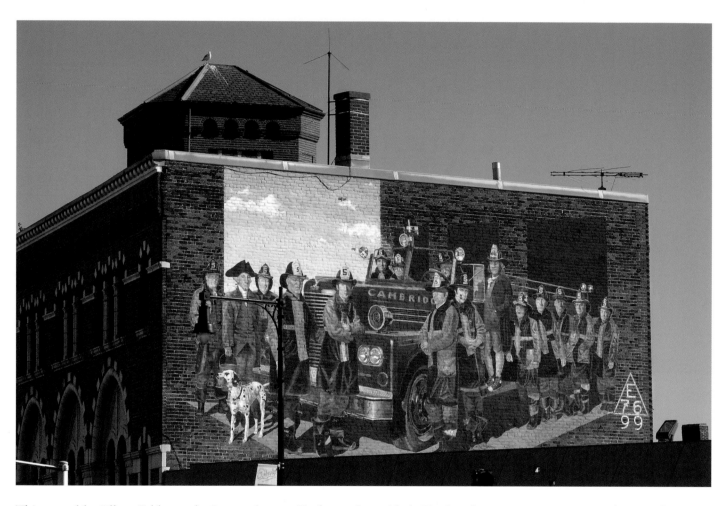

This mural by Ellery Eddy on the Inman Square Firehouse is entitled "Engine Company No. 5." Everything is three times life size, including the Dalmatian.

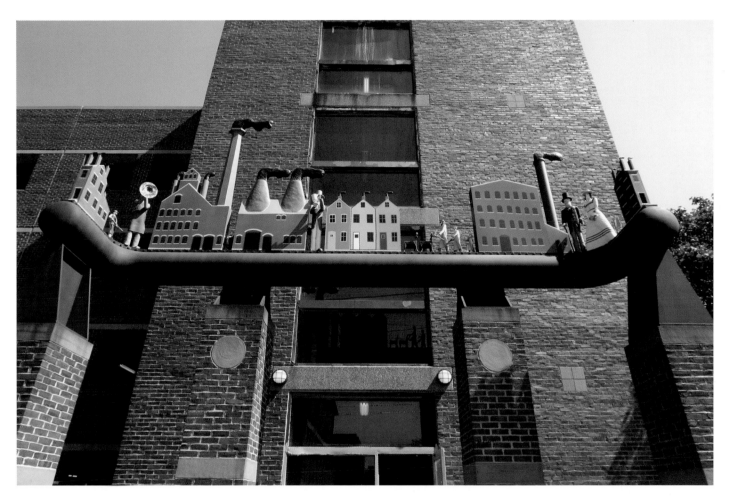

Cambridge has an abundance of public art, including this creation by George Greenamyer entitled "East Cambridge 1852." This work in forged, welded, and painted steel celebrates the furniture-making and glass-blowing industries that flourished in East Cambridge during the nineteenth century.

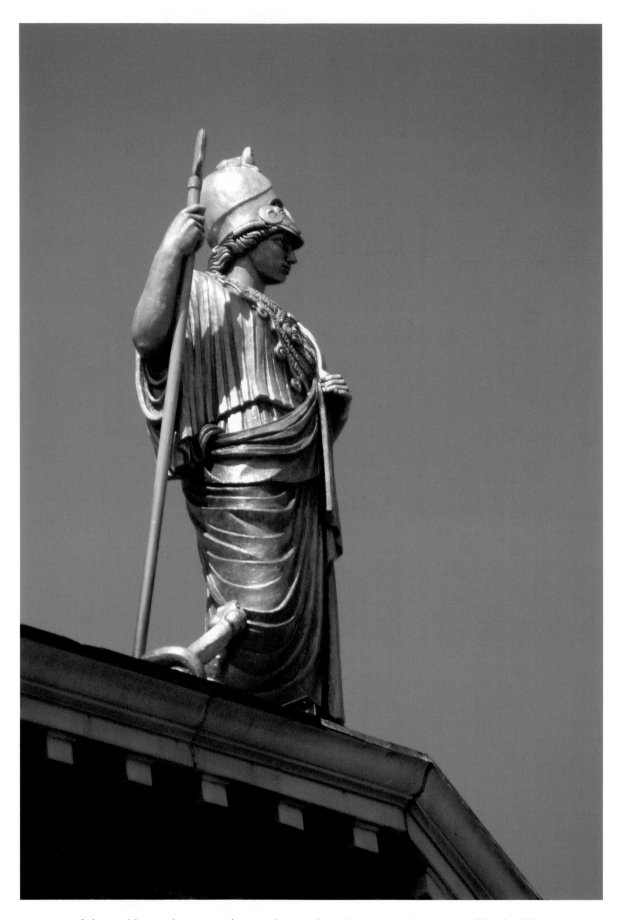

A statue of the goddess Athena stands guard atop the Athenaeum Center, an office building on First Street in East Cambridge.

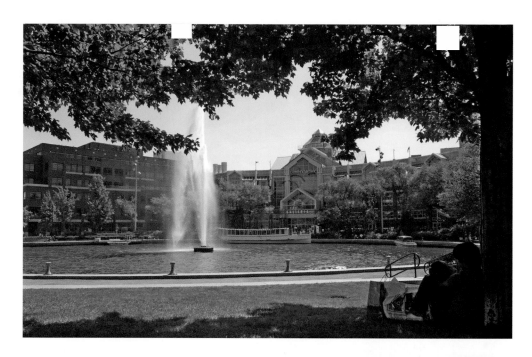

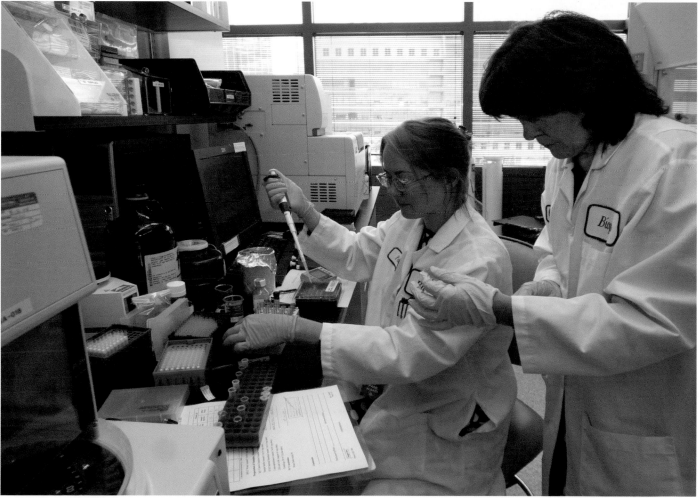

Top: The fountain flares in Canal Park behind the Cambridgeside Galleria Mall. Charles River and Boston Harbor cruises originate here aboard the S.S. *Henry Longfellow* and other vessels of the Charles Riverboat Company.

Bottom: Analysts work in a lab at Biogen Idec. Founded in 1978, the Cambridge-based company is a global leader in the discovery, development, manufacturing, and commercialization of biotechnology. Patients worldwide benefit from its pathmaking products for multiple sclerosis, lymphoma, and rheumatoid arthritis.

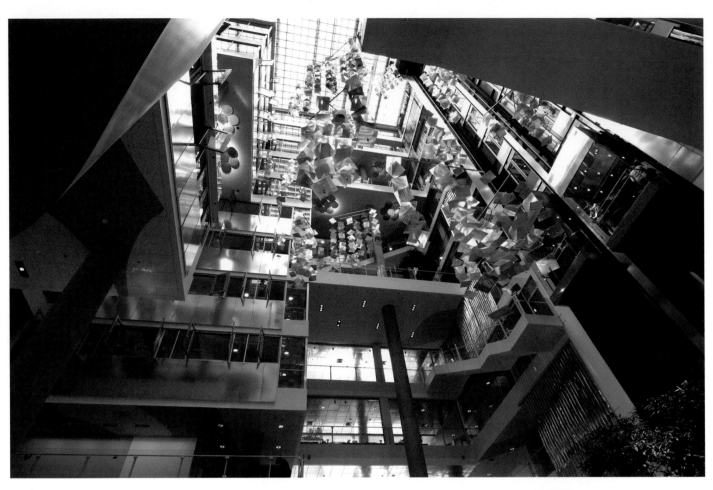

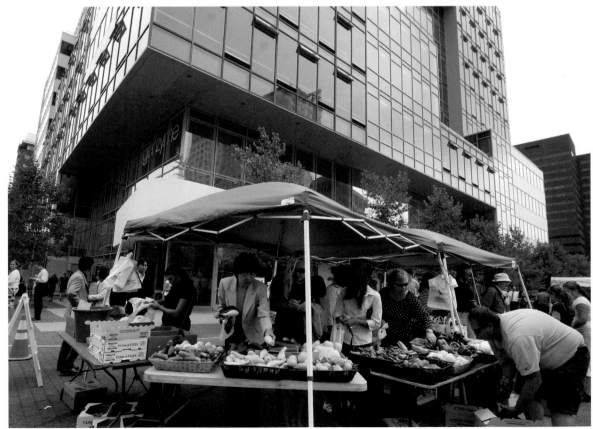

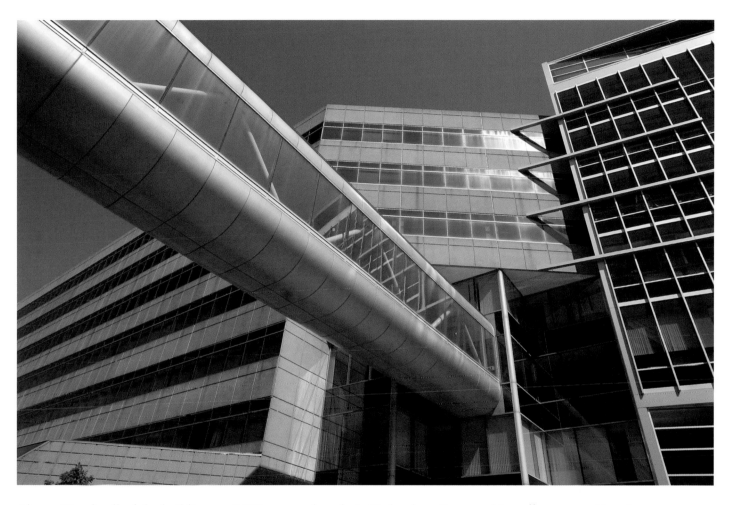

Above: Nearly all of the buildings at MIT are numbered. At Technology Square, this walkway over Broadway connects Building NE80 at One Hampshire Street with the Charles Stark Draper Laboratories.

Facing top: Genzyme, the Cambridge-based biotech giant, is acclaimed not only for its contributions to health care but also for its remarkable headquarters building, the Genzyme Center. The company says the center combines innovative design and cutting-edge technology to achieve two goals: creating an exciting workplace for more than 900 employees and setting a new standard in environmentally responsible architecture.

Facing bottom: Outside the Genzyme Center, noted for its "greenness," Cambridge residents can pick up fresh produce at a weekly farmers market.

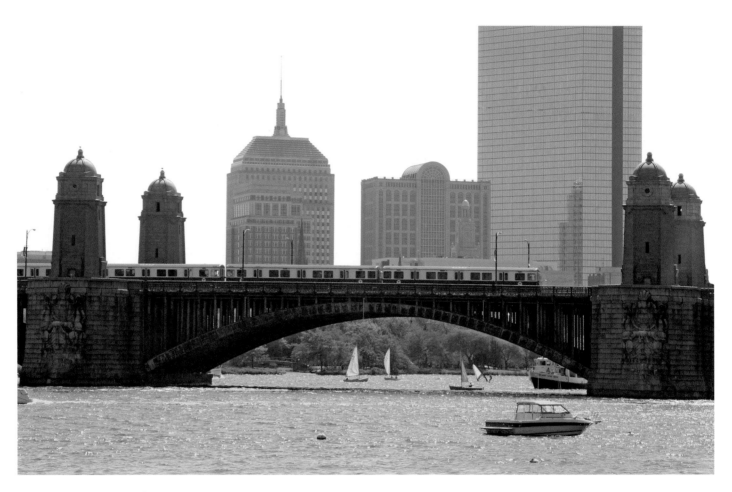

Originally known simply as the Cambridge Bridge, the Longfellow Bridge connects the Kendall Square area of Cambridge with Boston's Beacon Hill district. In addition to a roadway, the structure also known as the "Salt and Pepper Bridge" carries the MBTA's Red Line across the Charles River from downtown Boston to Kendall and Harvard squares, and beyond.

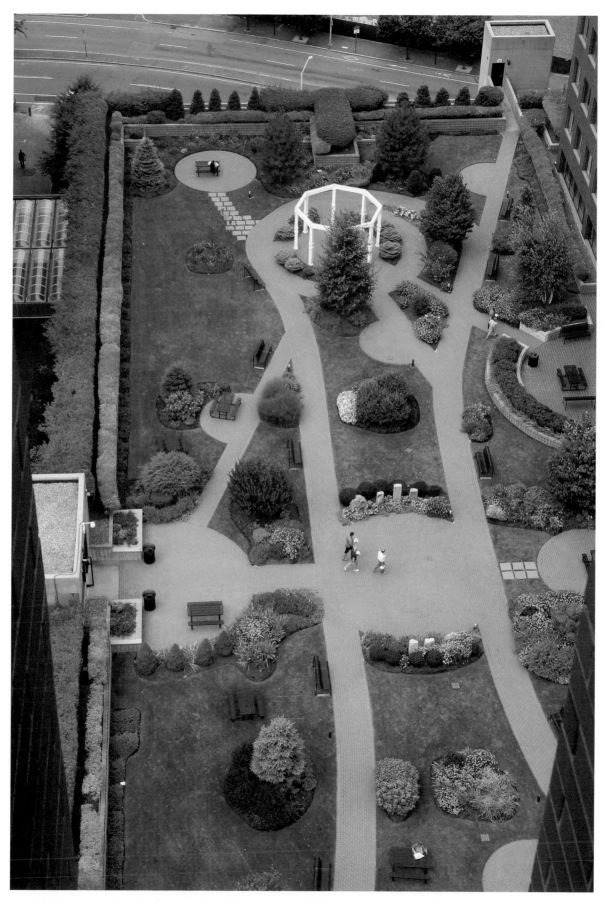

The Cambridge Center Roof Garden alongside the Boston Marriott Cambridge hotel provides a lunchtime oasis for the Kendall Square neighborhood.

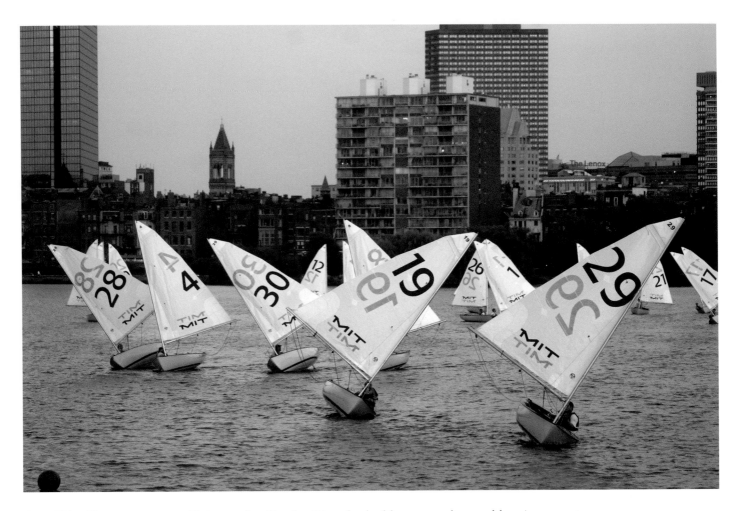

An MIT sailing regatta at twilight on the Charles River looks like a complex problem in geometry.

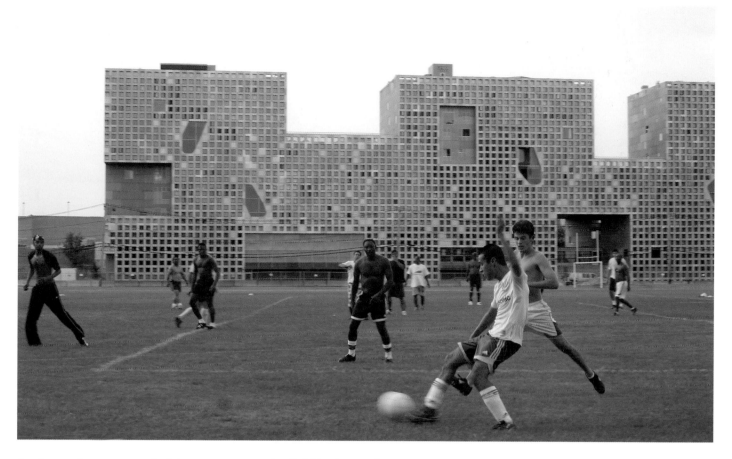

Students play a game of pick-up soccer on the field in front of Simmons Hall at MIT. The dormitory designed by Stephen Holt received the 2004 Harleston Parker Medal by the Boston Society of Architects, awarded since 1923 to the "most beautiful piece of architecture, building, monument, or structure" in the Boston area.

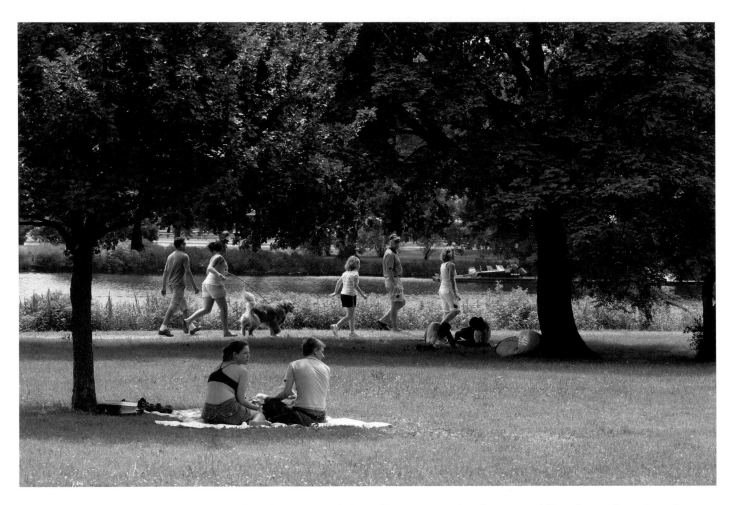

Above and facing: Memorial Drive is closed to automobile traffic on many Sundays, providing the perfect place for a promenade, stroll, or ride.

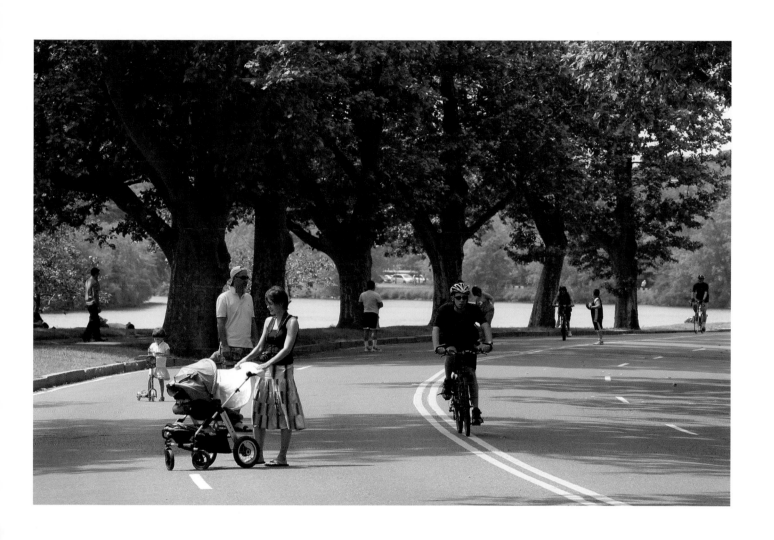

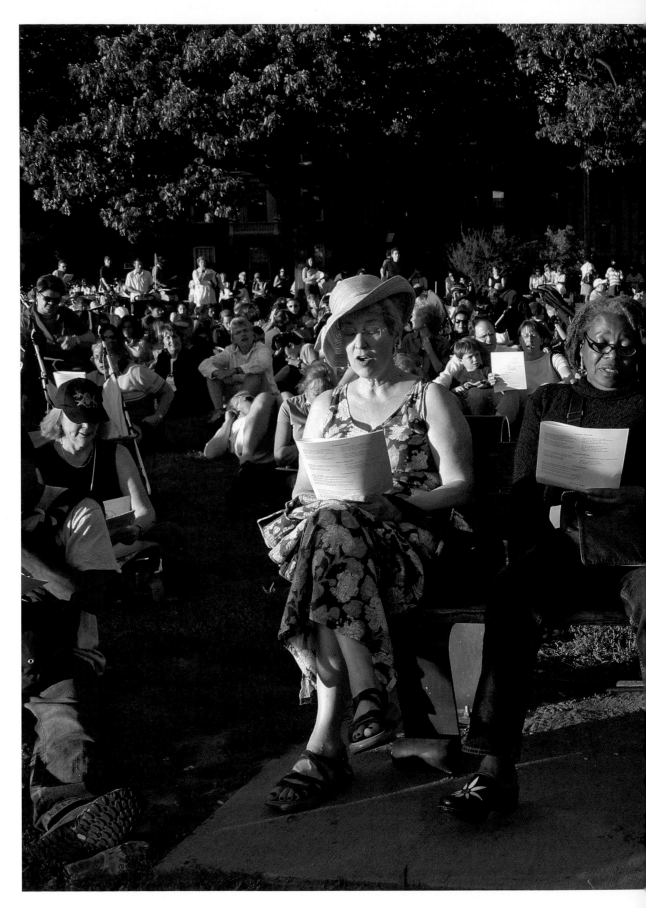

The annual Cambridge River Festival is a free one-day celebration of the arts along the banks of the Charles. Produced by the Cambridge Arts Council, it packs a mile-long stretch of Memorial Drive between JFK Street and Western Avenue with everything from jazz, world music, and dance to this enjoyable public sing-along.

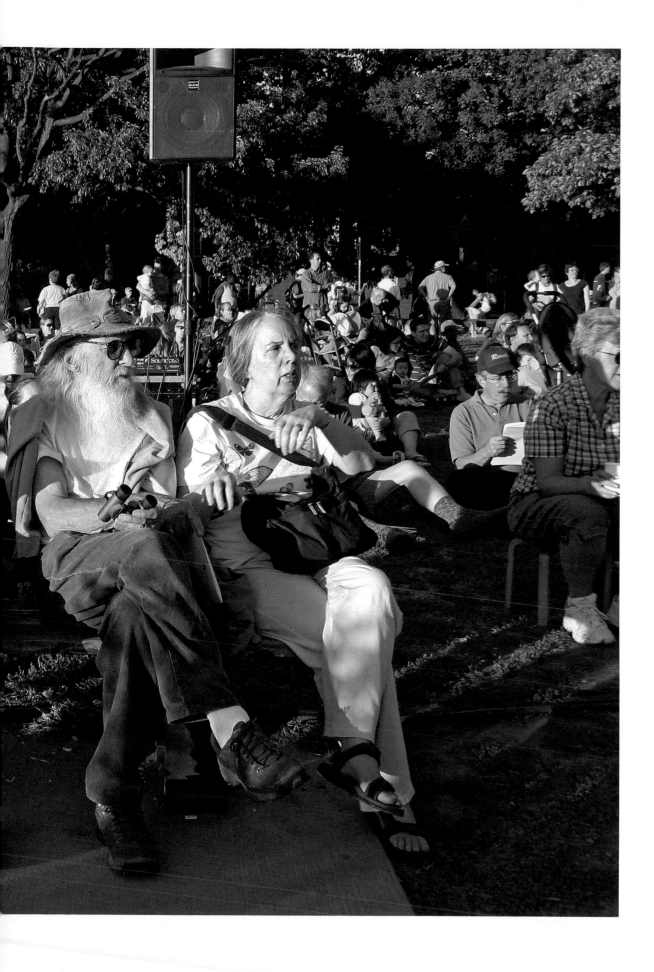

ULRIKE WELSCH

Ulrike Welsch was born in Bonn, Germany, during World War II, while her father was a brewmaster. He was also an amateur photographer, who did not live long enough to see his daughter excel in the field. In her teens, Ulrike (known as Uli) decided to become a druggist, an occupation that required knowledge of herbology, chemistry, cosmetics, health products, and photography. Uli quickly took a fancy to the darkroom, where she learned from a master printer. She began taking her own pictures with her father's Rodenstock.

After receiving her diploma, she began specializing in photography. In 1963, her mother died. To refresh her mind, Uli took a cruise to Greece and Egypt, where she met an American woman who offered to sponsor her in America. Uli wrote ahead to several camera stores in Boston, because New York seemed too big for comfort.

With her Rolleicord over her shoulder, she arrived by boat in the fall of 1964. She quickly landed a job in a Boston camera store and lived with four roommates, sharing one bathroom, on Beacon Hill. During lunch breaks, on weekends, and even at night, she took pictures, roaming the parks, the zoo, the Charles River, the markets. She made her own prints in her clothes closet with an enlarger she had brought from Germany.

Ulrike Welsch had her first one-woman exhibition in the Café Florian on Newbury Street. She sold images to the *Christian Science Monitor* and the

Boston Globe Sunday Magazine. After one year in the camera store, though, she felt that she had hit the wall. She spent a summer in Colorado teaching photography to children, and with her self-confidence at new heights, she approached the *Boston Herald Traveler* for a job. She was hired within a week—the first woman staff photojournalist at a Boston newspaper. She worked there for five years.

In 1972, Uli went to work for the *Boston Globe*. Editors there let her discover and develop artistically. She also covered some of the big Boston news events of the time. In 1977 the first comprehensive collection of her work, *The World I Love to See,* celebrated some of her discoveries.

In 1978 she took a seven-month leave of absence to photograph *Rituals in the Andes,* which she says taught her that "We don't need so much." In 1981, she ventured into a freelance career. Twenty-five years later, she is still exploring the world. Ulrike Welsch has taken pictures in Australia, Thailand, Mongolia, Turkey, India, Africa—the international list is long. But always she has come back to her home north of Boston and to New England, which she loves. A meeting with Commonwealth Editions publisher Webster Bull in 1998 has led to her eight most recent book projects: *Marblehead, Boston's North Shore, Boston Rediscovered, New England Rediscovered, Revolutionary Sites of Greater Boston, Boston At Its Best, Salem At Its Best,* and now *Cambridge At Its Best.*